J. M. W. TURNER
THE VAUGHAN BEQUEST

Christopher Baker

National Galleries of Scotland

EDINBURGH 2008

Published by the Trustees of the National Galleries of Scotland
© The Trustees of the National Galleries of Scotland 2006
Reprinted 2008

ISBN 1 903278 89 9 / 978 1 903278 89 5

Designed and typeset in Fontanova Indigo by Dalrymple
Printed in Belgium on Gardapat Kiara by Die Keure

Cover and frontispiece: details from *The Piazzetta, Venice*, 1840
[plate 26]

All illustrated works are by J. M. W. Turner unless otherwise specified

ACKNOWLEDGEMENTS
I am very grateful for the information and assistance I have
received from Ian Warrell (Tate Britain), Alan Crookham (The
National Gallery, London), Anne Hodge (National Gallery of
Ireland), Kim Sloan (The British Museum), Andrea Fredericksen
(University College London), Kay O. Walters (The Athenaeum),
Mrs J.B. Pateman (The Friends of Highgate Cemetery), Edwina
Ehrman (Museum of London), Stephen Humphrey (Southwark
Local History Library), the staff of the National Art Library
(Victoria & Albert Museum) and The Heinz Archive
(National Portrait Gallery, London).
C.B.

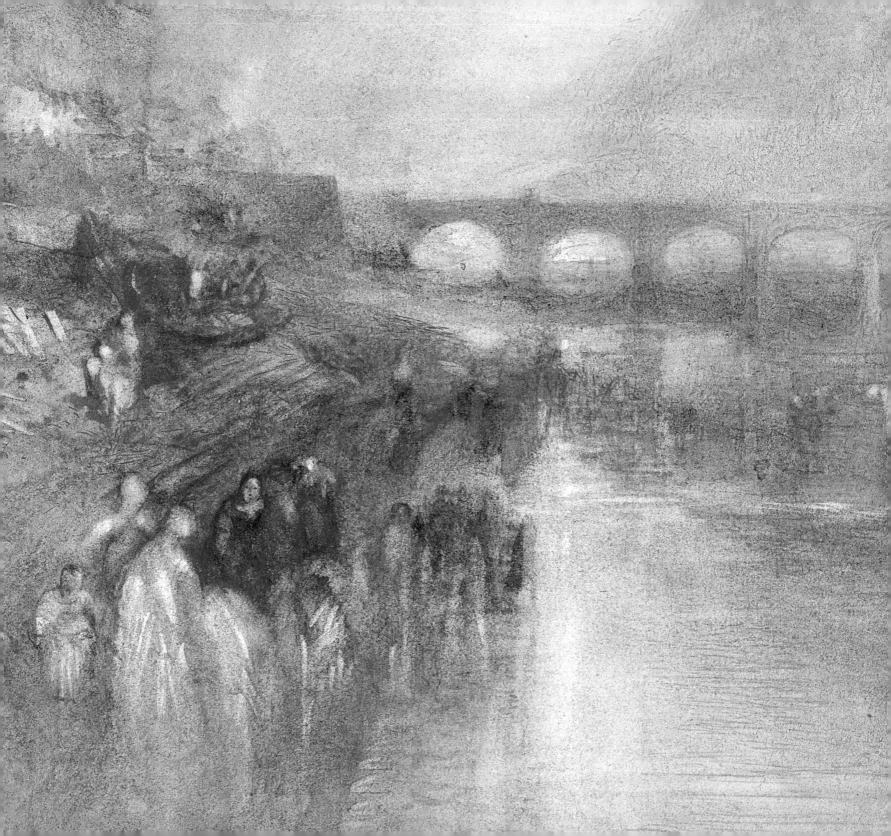

Foreword

Joseph Mallord William Turner (1775–1851) was perhaps the most prolific and innovative of British artists to take inspiration from the landscape, and his outstanding watercolours in the National Gallery of Scotland are one of the most popular features of its collection. Bequeathed to the Gallery by the distinguished collector, Henry Vaughan (1809–1899), they have been exhibited, as he requested, every January, for over one hundred years. Renowned for their excellent state of preservation, they provide a remarkable overview of many of the most important aspects of Turner's career. Vaughan's Turners illustrate his early studies under the patronage of Dr Monro in London in the 1790s, his gradual discovery of 'sublime' mountainous landscape in Wales, Scotland and the Alps, and what is undoubtedly one of the great highpoints of his maturity – the inspiration he drew from the light and art of Venice.

This book provides a commentary on the watercolours, addressing questions of technique and function, as well as considering some of the numerous contacts Turner had with other artists, collectors and dealers. The introduction concentrates on Henry Vaughan, one of the greatest enthusiasts for British art in the late nineteenth century, whose diverse collections have rarely been fully appreciated. Any new work on the Turners in Edinburgh is indebted to the earlier research of John Dick and Mungo Campbell, which we gratefully acknowledge here.

Vaughan built up an exemplary collection, which he wanted to be both carefully conserved and widely enjoyed – ambitions that have been respected. His bequest has, however, undoubtedly had another effect, as it has also inspired a number of more recent major gifts and acquisitions of works by Turner. These watercolours, which will be discussed in the forthcoming complete catalogue of English drawings, mean that the National Gallery of Scotland's collection now provides a remarkably rich overview of the achievement of one of the most accessible and admired of all Romantic artists.

JOHN LEIGHTON
Director-General, National Galleries of Scotland

MICHAEL CLARKE
Director, National Gallery of Scotland

< Detail from plate 38

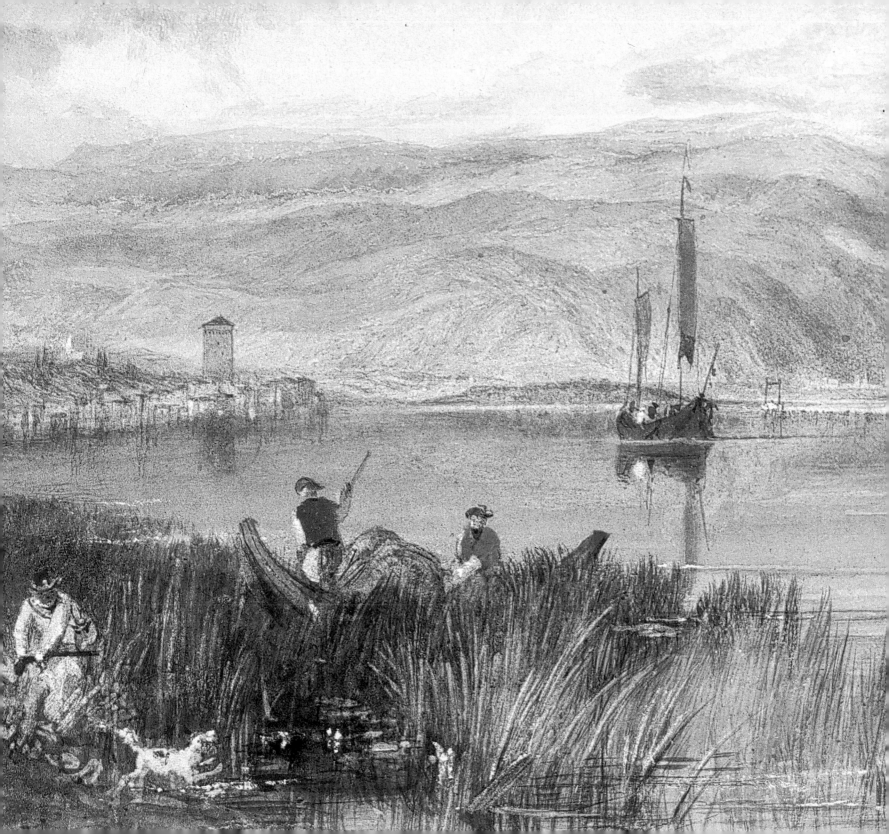

Henry Vaughan: 'A Great Turner Man'

In March 1886 Sir Frederick Burton, the Director of the National Gallery in London, received a letter offering a painting to the nation; the writer concluded by apologising 'for the trouble I would thus give you'. The picture was John Constable's *The Hay-Wain* (fig.1), and the collector making the gift so modestly was Henry Vaughan. The outstanding quality of the painting and Vaughan's almost apologetic tone are both typical of the collection he built, and the character of the man who created it. Vaughan was one of the most discerning and public-spirited of Victorian connoisseur-collectors, although undoubtedly among the most private and enigmatic. No portrait of him has come to light, and it is far from clear where he acquired many of the works of art he purchased. He bought, however, along with paintings by Constable, a splendid group of Turner watercolours – which is one of the great attractions of the National Gallery of Scotland's collection – and major drawings by Michelangelo and Rubens, among many other treasures. He also displayed remarkable generosity by donating his collections to museums and galleries across Britain and Ireland.[1]

There is little in Vaughan's background to suggest that he was going to become a man of such refined tastes. Born on 7 April 1809 in Southwark in south London, Henry Vaughan came from a Quaker family: his parents were Elizabeth Andrews[2] and George Vaughan, who was a successful local hat manufacturer. Although he later moved away from the area, Henry Vaughan retained his links with

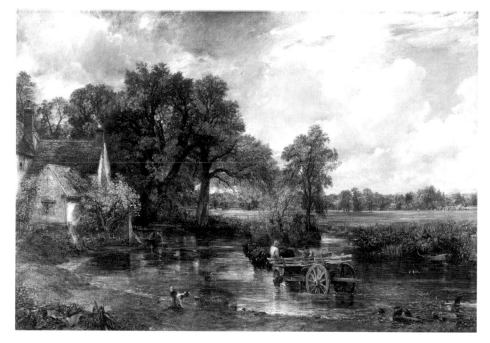

Fig.1 · John Constable (1776–1837)
The Hay-Wain
The National Gallery, London,
presented by Henry Vaughan

Southwark: in 1857 he paid for the building of some alms houses there which remained in use for the next fifty years.[3] This interest in philanthropy was sustained throughout his life.

Vaughan was privately educated in Walthamstow and as a boy became acquainted with the future prime minister, Benjamin Disraeli.[4] In 1828 he inherited a considerable fortune from his father and, although he spent liberally, at his death on 26 November 1899 he was recorded as still retaining just over £230,000. Such wealth provided him with the freedom not only to support charities, but also

< Detail from plate 8

to indulge the enthusiasms he had developed for travelling and collecting. How extensive his European tours were is hard to determine, but we can be certain that he visited Spain, as he mentions such a trip in his will, and also that he travelled in Italy; he is recorded as having bought a marble relief, which he thought was by Donatello, in Pisa.[5] He also attempted to speak Italian, although his mastery of the language was described as ' … something like Turner's – not recognising much distinction between Italian and French'.[6]

From 1834 Vaughan, who never married, lived with his sister at 28 Cumberland Terrace, on the east side of Regent's Park (fig.2). One of the most elegant buildings designed by John Nash (1732–1835), who was a friend of Turner, it was completed about six years earlier. An impression of how Vaughan's collection was stored and displayed in this grand townhouse is conveyed by lists of his property.[7] These show, for example, that he had an iron safe in his bathroom in which he kept his collection of coins, and that his works by Constable were chiefly hung in the dining room, while the Turner watercolours appear to have been distributed around the house, some framed, although most kept in portfolios. The overall effect of the interiors must have been extraordinarily rich and eclectic: in addition to paintings and drawings, Vaughan's possessions included a telescope, silverware, bronzes, ivories, larger sculptures and reliefs, stained glass, Venetian glass, a table with a Roman mosaic top, frames from Siena and Venice, Rembrandt etchings and Spanish clocks. The stained glass was particularly notable and included a group of medieval and later fragments, now in the Victoria & Albert Museum, London (fig.3). The display of such an abundance and variety of objects was typical of mid-nineteenth-century interior design, although the quality of some of the works of art at Cumberland Terrace was exceptional.

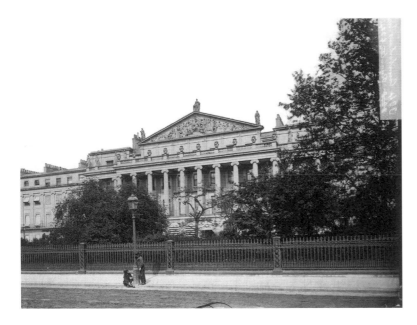

Fig.2 · Cumberland Terrace, on the east side of Regent's Park, London, photographed by York and Son c.1870–1900
National Monuments Record

Fig.3 · Stained Glass, English 1340–5
Annunciation to the Shepherds
Victoria & Albert Museum, London, bequeathed by Henry Vaughan

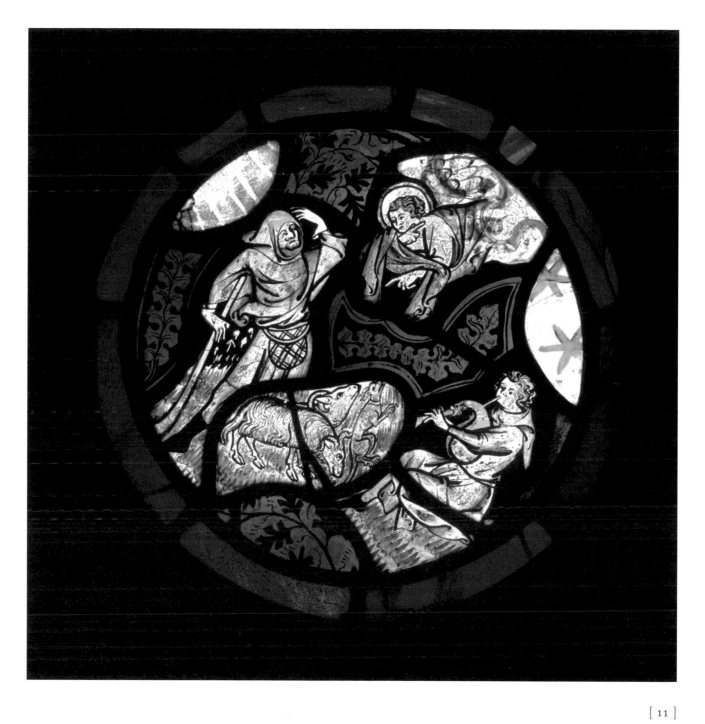

Vaughan created a small and idiosyncratic old master collection that featured a few minor paintings, now in London's National Gallery, the earliest of which is a fragment from a fifteenth-century Tuscan fresco.[8] He also acquired, however, a much broader selection of drawings, which were presented to the British Museum, that far more effectively illustrate the refinement of his taste. Among them are some outright masterpieces, including superb examples of the art of Raphael, Michelangelo (fig.4), Rubens (fig.5), Rembrandt (fig.6), Claude (fig.7) and Watteau.[9] Vaughan bought such studies either one by one or in small groups, apparently pursuing personal preferences, rather than building up a survey collection. The Michelangelo, for example, he acquired, along with four other works associated with the artist, at the 1860 Woodburn sale held in London;[10] he was able to secure the most expensive drawing in this batch for £45 3s.[11] Vaughan was also interested in prints associated with his drawings, and purchased a fine group of Rembrandt etchings that are now in the collection of University College, London.

The Burlington Fine Arts Club, of which Vaughan became a founder member in 1866, provided an inspiring context in which he could develop his appreciation of such old masters – as well as more recent British art. A private club for artists and connoisseurs, its members included the painters Dante Gabriel Rossetti and Hercules Brabazon Brabazon (another Turner enthusiast), along with a number of collectors, writers and antiquaries, whose interests ranged from the

Fig.4 · Michelangelo Buonarroti (1475–1564)
Seated Nude Man
The British Museum, London, presented by Henry Vaughan

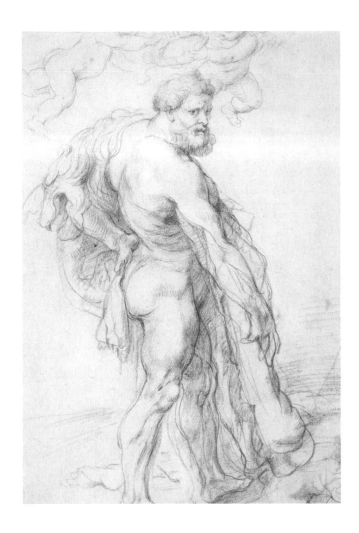

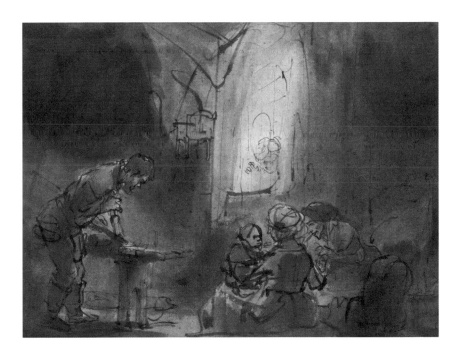

Fig.5 · Sir Peter Paul Rubens (1577–1640)
Hercules Standing on Discord, Crowned by Two Genii
The British Museum, London, bequeathed by Henry Vaughan

Fig.6 · Rembrandt van Rijn (1606–1669)
The Holy Family in the Carpenter's Workshop
The British Museum, London, bequeathed by Henry Vaughan

Fig.7 · Claude Lorrain (1604/5–1682)
A Storm at Sea
The British Museum, London, bequeathed by Henry Vaughan

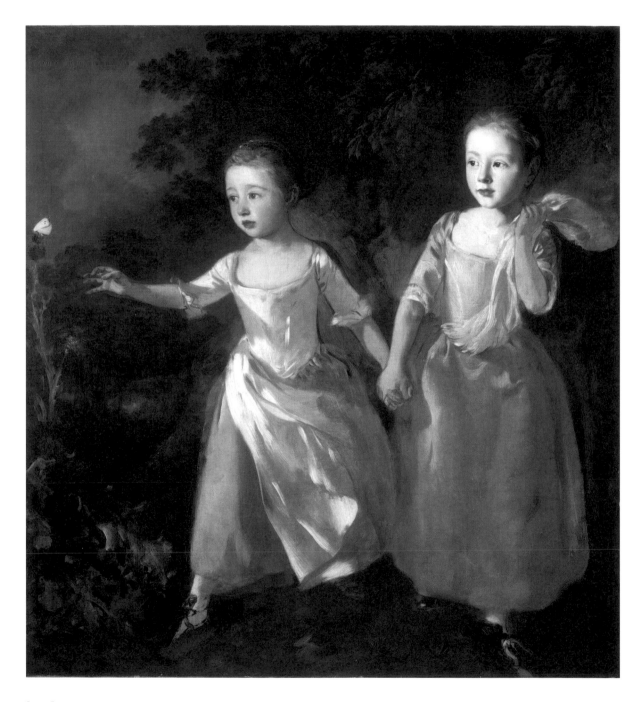

Fig.8 · Thomas Gainsborough
(1727–1788)
*The Painter's Daughters Chasing
a Butterfly*
The National Gallery, London,
bequeathed by Henry Vaughan

Renaissance to the nineteenth century. The club at first held informal gatherings in members' houses to discuss their possessions – and it is tempting to imagine such an evening in Vaughan's home. But it was soon decided to rent a building, 17 Savile Row, for meetings and exhibitions; the latter were never seen by large numbers of visitors, but were none theless significant as scholarly exercises.[12] Vaughan often lent works from his collection to these exhibitions: for example, thirteen drawings and prints included in the 1870 exhibition which celebrated the work of Raphael and Michelangelo.[13]

BRITISH ART

Although he made such important historical acquisitions, it was above all eighteenth and nineteenth-century British art which Vaughan admired, and which came to form the largest part of his collection. Among the most conspicuous of the British pictures he purchased was perhaps Gainsborough's *The*

Painter's Daughters Chasing a Butterfly (fig.8),[14] a tender celebration of childhood and a spirited demonstration of fluid painting. As an unfinished picture it may well have particularly appealed to Vaughan, because he had developed an interest in informal works in oil that reveal artists's working methods; he also acquired fifteen of Constable's finest preparatory oil sketches, which span much of the artist's career (fig.9).[15]

Vaughan was one of the earliest collectors of Constable's sketches, and in 1870 was willing to pay £43 1s for an example of such work (only slightly less than he had spent ten years earlier on a Michelangelo). It also appears that he made purchases directly from the Constable family, whom he visited in 1874 and 1875.[16] The only finished painting by Constable that Vaughan acquired was *The Hay-Wain*, which had been painted in 1821, and was famously during its early life more admired when exhibited in France than in Britain.[17] Vaughan

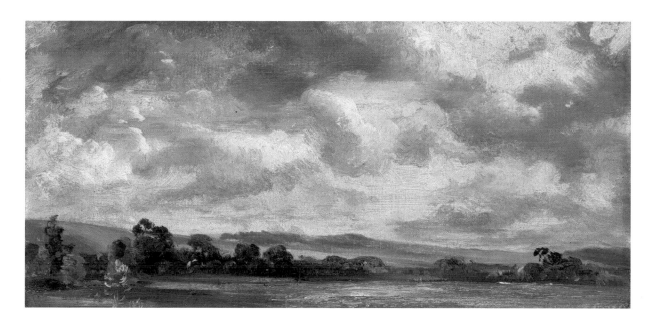

Fig.9 · John Constable (1776–1837)
Harnham Ridge
Tate Britain, bequeathed by
Henry Vaughan

bought it at auction in 1866, and in spite of the critical indifference around him, was well aware of the painting's merits. He compiled an album in which he gathered information on the picture, and lived with it for twenty years before presenting it to the nation. He hoped to make the presentation confidentially, but this proved impossible and only five days after his offer was made it was announced in the House of Commons (prompting cheers of approval) and reported in *The Times*.[18]

Vaughan's interest in British art was by no means confined to Gainsborough and Constable; a visitor to Cumberland Terrace would have been able to admire paintings and drawings by a wide range of artists encompassing the full spectrum of late Georgian and high Victorian taste. They included works by Thomas Rowlandson, Sir Joshua Reynolds,

John Flaxman, Thomas Stothard, Sir Thomas Lawrence, John Opie, Sir Augustus Wall Callcott, William Hilton, William Mulready, Patrick Nasmyth, Charles Robert Leslie, James Holland, Edward William Cooke, Sir John Everett Millais and Lord Frederic Leighton.[19] Among these perhaps two names stand out, in terms of Vaughan's enthusiasm: Flaxman and Stothard.

The drawings of the neoclassical designer and sculptor John Flaxman evidently particularly appealed to Vaughan, as he acquired over sixty, which are now in the British Museum. Perhaps less well known today, but clearly also of great interest to the collector were the watercolours and oil paintings of Thomas Stothard, who in the early nineteenth century enjoyed considerable success as a literary illustrator. Stothard was closely associated

Fig.10 · Thomas Stothard (1755–1834)
Illustration to Sir Walter Scott's 'Rokeby'
National Gallery of Scotland, bequeathed by Henry Vaughan

Fig.11 · John Henry Foley (1818–1874)
Sir Joshua Reynolds
Tate Britain, bequeathed by Henry Vaughan

with Turner's friend, the poet Samuel Rogers, and Turner is reported to have remarked 'If I thought [Stothard] liked my pictures as well as I like his, I should be satisfied.' As Vaughan came to idolise Turner such approval may well have persuaded him of the merits of Stothard's work. He bequeathed twenty-four of Stothard's watercolours to the National Gallery of Scotland, appropriately selecting for Edinburgh only illustrations to works by Robert Burns and Sir Walter Scott (fig.10).[20]

Vaughan's enthusiasm for British artists extended far beyond simply buying works of art. He also commissioned life-size marble sculptures of his heroes, Reynolds (fig.11), Flaxman and Gainsborough. The first two portraits were almost certainly displayed in Vaughan's home, and illustrate in a very compelling fashion the extent of his regard for the achievements of these men. The portrait of Gainsborough was, however, completed in 1906 under the terms of Vaughan's will, and all three are now in the collection of Tate Britain.[21]

TURNER

At the heart of his devotion to British art was Vaughan's appreciation of the work of Turner (fig.12) – the artist he collected most systematically and thoughtfully. His Turners were described without exaggeration in one of his obituaries as 'singularly choice and indeed hardly paralleled in this country.'[22] The extent of his Turner collection was considerable: thirty-eight watercolours came to the National Gallery of Scotland, thirty-one to the National Gallery of Ireland, twenty-three to the National Gallery, London (they are now integrated with the Turner Bequest at Tate Britain), and six passed to the Victoria & Albert Museum; the British Museum received nearly one hundred proofs of Turner's *Liber Studiorum* prints from Vaughan and

Fig.12 · Charles Turner (1774–1857)
Joseph Mallord William Turner (1775–1851)
Scottish National Portrait Gallery, Edinburgh

twenty-three associated drawings, while University College London was given the rest of his *Liber* prints. The whole collection amounted to a comprehensive overview of Turner's work on paper, illustrating the extraordinary diversity of his output. It included, for example, a crisp documentary drawing made on the quarterdeck of Nelson's flagship HMS *Victory* dated 1805 (fig.13), as well as late ethereal masterpieces by the artist, such as his *The Lauerzer See, with the Mythens* of about 1848 (fig.15). The significance of the collection was soon recognised and works from it were integrated into the first great catalogue of Turner's own bequest, which was written by A.J. Finberg and published in 1909.[23]

Vaughan's only known publication focused on Turner: in 1872, with the collector J.E. Taylor, he wrote the catalogue for the *Exhibition Illustrative of Turner's 'Liber Studiorum'* held at the Burlington Fine Arts Club.[24] This pioneering work was one of the earliest studies of this aspect of Turner's output. The *Liber Studiorum* ('Book of Studies') was a large series of engravings after landscape compositions by Turner, the production of which he supervised.

Among his finest achievements, the project was a means of disseminating his work and retaining control – in terms of quality – over it. The initial plan was to publish the *Liber* with a frontispiece (fig.14) in twenty parts, each consisting of five plates. Turner made watercolour studies for the printmakers with whom he worked, and by 1819 seventy-one prints had appeared (twenty others are known through proofs). The artist saw them as examples of types of landscapes, such as pastoral or epic (see fig.32), and clearly intended that they should function as a promotional and inspiring survey. The *Liber* was perhaps most admired by collectors and artists from the 1860s to the 1920s, when its didactic role was still valued, and so Vaughan stands at the threshold of this period of appreciation.

When acquiring works connected with the *Liber* series and other watercolours by the artist, Vaughan was essentially a second generation Turner collector. The Edinburgh and Dublin works illustrate this particularly effectively: they were not directly acquired from the artist, but had in a number of cases passed through the collections of men who

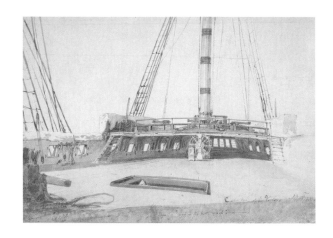

Fig.13 · *The Quarterdeck of the 'Victory'* 1805
Bequeathed by Henry Vaughan to the National Gallery, London, transferred to the Tate Gallery

Fig.14 · *Frontispiece to the Liber Studiorum*
Bequeathed by Henry Vaughan to the National Gallery, London transferred to the Tate Gallery

had contact with him, such as William Bernard Cooke (1778–1855), Charles Heath (1785–1848), Benjamin Godfrey Windus (1790–1867) and Charles Stokes (1785–1853). Cooke and Heath were both engravers, who worked with Turner on a number of major printmaking projects, while Stokes and Windus were wealthy Turner enthusiasts. Stokes had made his money from stockbroking, and Windus was a coach maker, whose fortune derived from selling a cordial containing opium which was supposed to act as a throat remedy. The wealth this generated allowed him to create what was probably the greatest private collection of Turners ever assembled. Housed in his library at Tottenham, the collection was opened to the public one day a week, and memorably depicted in 1835 by John Scarlett Davis (fig.16). The Windus collection included three works that eventually formed part of Vaughan's bequest to Edinburgh: the two Abbotsford vignettes and the magnificent watercolour of *Llanberis Lake and Snowdon* (plates 13, 14, 17). Davis's watercolour survives in its original frame, which is similar in style to the frames used for the Turners in the Windus collection, and so gives an impression of how the three Edinburgh works may have been displayed originally.

It is also very likely that Vaughan used the art dealer Thomas Griffith (b.1795) to help build his collection. Griffith, who trained as a lawyer, was promoting the sale of works by Turner from as early as 1827, at first on behalf of the artist and later selling on works he had acquired. He lived at Norwood, and opened a gallery in Pall Mall in 1845. Throughout his

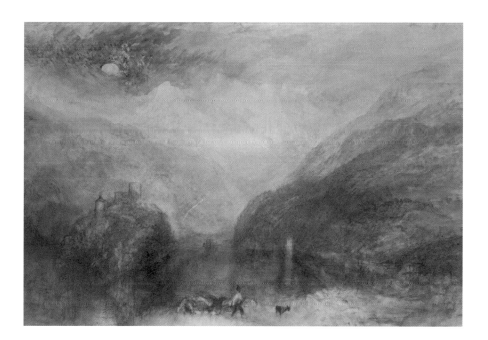

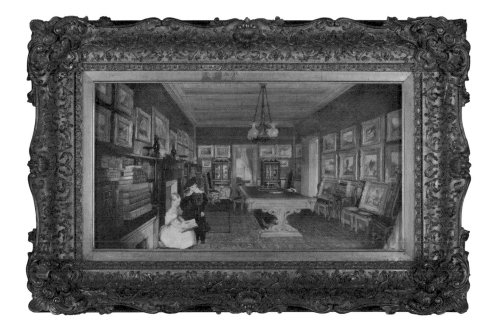

Fig.15 · *The Lauerzer See, with the Mythens*
Victoria & Albert Museum, London, bequeathed by Henry Vaughan

Fig.16 · John Scarlett Davis (1804–1844)
The Library at Tottenham, the Seat of B.G. Windus, Esq.
The British Museum, London

life he seems to have handled a wide range of Turner's work, including particular aspects of it which came to feature in Vaughan's collection, such as watercolours from the artist's England and Wales series, *Liber Studiorum* proofs, and Swiss views. It is possible that it was through an intermediary such as Griffith that Vaughan and Turner actually met. They may also have made contact because they were both members of The Athenaeum Club in London; however, this is by no means certain as Turner, who could be notoriously unsociable, apparently usually sat in a dark corner with a bottle of sherry when he visited his club. A probable discussion between them about the *Liber Studiorum* in 1840–2 is though recorded in a later anecdote.[25]

Turner's most effective champion, the great critic John Ruskin (fig.17), was undoubtedly aware of Vaughan's reputation as a collector. Ruskin wrote to his secretary from Interlaken on 26 May 1866:

All you have done is right except sending Mr Henry Vaughan about his business. / He is a great Turner man. Please write to him that he would be welcome to see everything of mine, but I would rather show them to him myself. [26]

Ruskin appears to have repaid the compliment, as he probably visited and studied Vaughan's Turners, and made a faithful copy of a detail from his watercolour of *Llanberis Lake and Snowdon* (fig.33). Ruskin's study was later engraved as an illustration for the fifth volume of *Modern Painters* (1843–60), his most ambitious work, which was initially planned as a defence of Turner's art.

The remarkable combination of high-minded ideals and practical programmes of action that Ruskin embodied appears to have proved inspirational to Vaughan. It is likely that the scope of Vaughan's collection, which ranged from gothic

glass to Turner watercolours was shaped by the comparably broad sweep of Ruskin's own interests. But more specifically, Ruskin certainly influenced Vaughan's decision about how to dispose of his collection. In Vaughan's will of 1887 he made it clear that the Dublin and Edinburgh bequests were to be used in the same way as the Turners that Ruskin had presented to the Fitzwilliam Museum in Cambridge in 1861. Ruskin gave a fine representative group of twenty-five of his Turner watercolours to Cambridge (having earlier donated a collection to

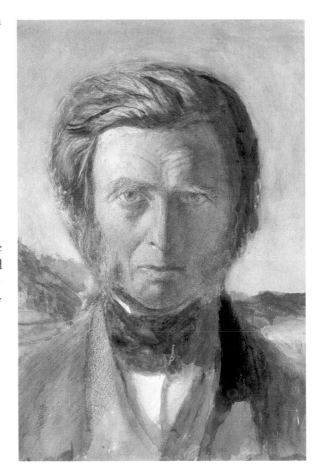

Fig.17 · Charles Fairfax Murray (1849–1919)
Portrait of John Ruskin (1819–1900)
Tate Britain (Oppé Collection)

Oxford), and stated that his hope was that they would: '… illustrate Turner's modes of work at various periods of his life … [so] they may be useful for reference and … example to the younger Students who take interest in the study of English art and the practice of drawing'.[27] Vaughan was therefore continuing and expanding Ruskin's educational programme, as the Edinburgh and Dublin works admirably exemplify Turner's 'modes … at various periods of his life …' His selections for the two collections give a remarkably effective overview of the range of his achievement and working methods, by covering the artist's work from the 1790s to the 1840s, touching on his printmaking projects and European tours, and including studies created before nature (fig.18), as well as highly resolved studio works (fig.19).

Vaughan was far from being alone in taking inspiration from Ruskin in this way: numerous other gifts to public collections (and indeed the establishment of complete galleries) were fired by his belief in the uplifting and informative role of art.[28] Another collector who looked to Ruskin in a similar fashion was John Edward Taylor (1830–1905), whose experience parallels that of Vaughan quite closely. Taylor inherited wealth from his father (the founder of the *Manchester Guardian*), lived in some splendour in Kensington Palace Gardens in London, built a magnificent collection of fine and decorative arts, including Turner watercolours, and made gifts to public museums.[29]

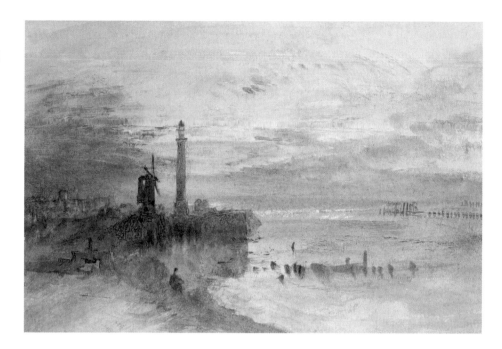

Fig.18 · *Great Yarmouth Harbour, Norfolk*
National Gallery of Ireland, Dublin,
bequeathed by Henry Vaughan

Fig.19 · *A Ship Against the Mew Stone, at the Entrance to Plymouth Sound*
National Gallery of Ireland, Dublin,
bequeathed by Henry Vaughan

Ruskin's influence was so pervasive that it even affected Vaughan's plans for storing his bequests of Turner watercolours. The works destined for Edinburgh and Dublin arrived with specially designed cabinets; the National Gallery of Ireland's still survives (fig.20), although unfortunately there is no trace of the Edinburgh example. The Dublin cabinet broadly follows the practical designs Ruskin devised for his own gifts to public collections.[30] The watercolours are framed, stored in the cabinet vertically, and can be viewed individually on an attached fold-down table when not exhibited.[31]

As well as being concerned about physical storage, Vaughan took seriously the question of how his bequests were displayed. He stipulated that his works for Edinburgh should be exhibited 'all at one time free of charge during the month of January'. In limiting their exposure in this way, he demonstrated his awareness of a wide-ranging discussion in the second half of the nineteenth century about whether watercolours faded when exposed to light. The debate raged in the newspapers; some commentators noted serious damage to over-exposed works in public collections, while others failed to see such problems and even suggested light could enrich the appearance of watercolours.[32] After experimentation which determined that pigments did indeed fade, broad consensus was reached, and Vaughan was clearly of the view, which is consistent with modern conservation guidelines, that to preserve such works their display should be restricted. His foresight means that the watercolours are notable for their remarkably fine condition.

Fig.20 · The cabinet in which the Vaughan Bequest of Turner watercolours was presented to the National Gallery of Ireland, Dublin.

Vaughan's decision to ensure that part of his collection should go to Edinburgh may have been prompted by knowledge that although Turner visited Scotland on six occasions, and these experiences were a source of profound inspiration to him, his work was very poorly represented there. It had been exhibited in loan exhibitions; for example, between 1845 and 1851 ten oil paintings by the artist were lent to the Royal Scottish Academy, [33] and between 1869 and 1889 there were regular displays of watercolours from Turner's own bequest to the nation at the National Gallery of Scotland.[34] These were sent up from London by train and exhibited from each November for a year (with no regard for the likelihood of fading). In spite of these initiatives, hardly any works by Turner could be seen permanently in Scottish public collections.

Vaughan had already been generous to Edinburgh, because in 1886 he had lent two of his finest Constables to the International Exhibition in the city. He must also have given some thought to the appropriateness of including Turner's illustrations to Sir Walter Scott's works in his bequest, but he can hardly have anticipated its far-reaching effects. The exhibition of the Vaughan Bequest of Turner's drawings and watercolours every January since 1900 has become an extraordinarily popular event, which lifts the spirits during the dark days of an Edinburgh winter. His works have also formed the basis of a growing collection, as they have undoubtedly prompted important subsequent gifts and acquisitions, including that of Turner's only complete set of literary vignettes – the illustrations he created for Thomas Campbell's poems – which entered the collection in 1988. These, along with other major acquisitions, such as Turner's spectacular watercolour *Bell Rock Lighthouse* and two illustrations he made for Scott's *Provincial Antiquities and Picturesque Scenery of Scotland*, mean that that National Gallery of Scotland is now a vital stop for any serious student of the artist's work.

* * *

Henry Vaughan was buried in Highgate in London at the top of the western section of its cemetery, just opposite the memorial to George Wombwell, the creator of Victorian Britain's most famous menagerie. His tomb, which contains a family vault, is relatively austere, and – in a manner typical of his habitual discretion – carries no inscriptions referring to his interests or generosity.[35]

Vaughan was a private and cultivated man, comfortably able to pursue his passions at a time when prices for paintings and drawings were gradually increasing. The breadth of his taste at first appears to be undisciplined; however, he brought to his collecting a seriousness and rigour through its focus on Turner and Constable, whose work had often divided other collectors and critics. He also clearly endorsed John Ruskin's belief that carefully selected works of art could inspire a growing gallery-going public. Over a century after Vaughan's death the admirable ambitions of both men continue to be fulfilled through his bequests of works by Turner to London, Dublin and Edinburgh.

Henry Vaughan: A Chronology

1809
Born, Southwark, South London.

1828
Inherits a fortune from his father, a successful local hat manufacturer.

1833
The sale of the collection of Dr Thomas Monro, which included many works by Turner (Christie's 26–28 June); it is possible that Vaughan may have made some acquisitions at this sale.

1834
Moves to 28 Cumberland Terrace, Regent's Park.

1837
Death of John Constable.

1840–2
A possible meeting with Turner, and discussion of the *Liber Studiorum*.

1848
Becomes a member of The Athenaeum Club (Turner is also a member). Visits University College London, and offers a benefaction of £5,000 to remain anonymous until after his death; the gift is made on behalf of his mother, following her recovery from an illness, and is used for scholarships.

1851
Death of J.M.W. Turner.

1852
Vaughan commissions from the Swiss artist Alexandre Calame (1810–1864) a painting *The Lake of Thun*; completed two years later, it is now in the collection of the National Gallery, London.

1853
The sale of the collection of Benjamin Godfrey Windus (Christie's 20 June); it featured works by Turner which Vaughan was to acquire.

1856
Turner's bequest to the nation.

1857
The *Art Treasures of the United Kingdom* exhibition, Manchester; Vaughan lends Turner's *Llanberis Lake and Snowdon, Caernarvon, Wales*. He pays for the building of alms houses in Southwark which remain in use until 1907.

1858
Ruskin's report on the Turner bequest to the nation. It included the suggestion that small collections illustrating Turners 'modes of practice' could be selected for collections in Edinburgh and Dublin.

1860
The Woodburn sale in London; Vaughan buys works by Michelangelo and Raphael.

1861
Ruskin makes a gift of works by Turner to the University of Cambridge; later this is cited by Vaughan as a precedent for his own bequests.

1862
Vaughan lends works by Constable to the British Institution and South Kensington Museum.

1866
Vaughan buys John Constable's *The Hay-Wain*; becomes a founder member of the Burlington Fine Arts Club and attempts to view the works by Turner in the collection of John Ruskin.

1868
Vaughan lends a Constable to the *National Exhibition of Works of Art* in Leeds.

1869–89
Annually, groups of watercolours from Turner's bequest to the nation are sent to Edinburgh and exhibited at the National Gallery of Scotland. The exhibitions start each November and last for a year.

1870
Vaughan lends works to the Raphael and Michelangelo exhibition at the Burlington Fine Arts Club.

1871
Vaughan lends works by Constable, Gainsborough and Reynolds to the old masters exhibition at the Burlington Fine Arts Club.

1872
The exhibition on Turner's *Liber Studiorum* at the Burlington Fine Arts Club; Vaughan is a key lender and co-author of the catalogue.

1874
Completion of the marble portrait of Reynolds that Vaughan commissioned from John Henry Foley (fig.11).

1874–5
Vaughan visits members of John Constable's family.

1879
Vaughan is elected a Fellow of the Society of Arts.

1886
Vaughan presents *The Hay-Wain* to the National Gallery, London; he requests that the gift is anonymous, but this proves impossible. He also lends two Constable oil sketches to the *International Exhibition* in Edinburgh.

1887
Vaughan draws up his will. His collection is to be chiefly divided between the National Gallery of Scotland, the National Gallery of Ireland, the National Gallery in London, the British Museum, the Victoria & Albert Museum and University College London. Vaughan also specifies a number of charitable bequests. He presents works by Michelangelo to the British Museum.

1899
Death of Henry Vaughan. His fortune at his death is just over £230,000. He is buried in Highgate Cemetery.

1900
Death of John Ruskin. The first display of the Vaughan Turners in Edinburgh.

1901
The publication of the first catalogue of the National Gallery of Scotland's collection which includes the Vaughan Turners.

1906
Completion of a sculpted portrait of Gainsborough by Thomas Brock (now in Tate Britain), commissioned under the terms of Vaughan's will.

1909
The first catalogue of the Turner Bequest is published and some of Vaughan's works are included.

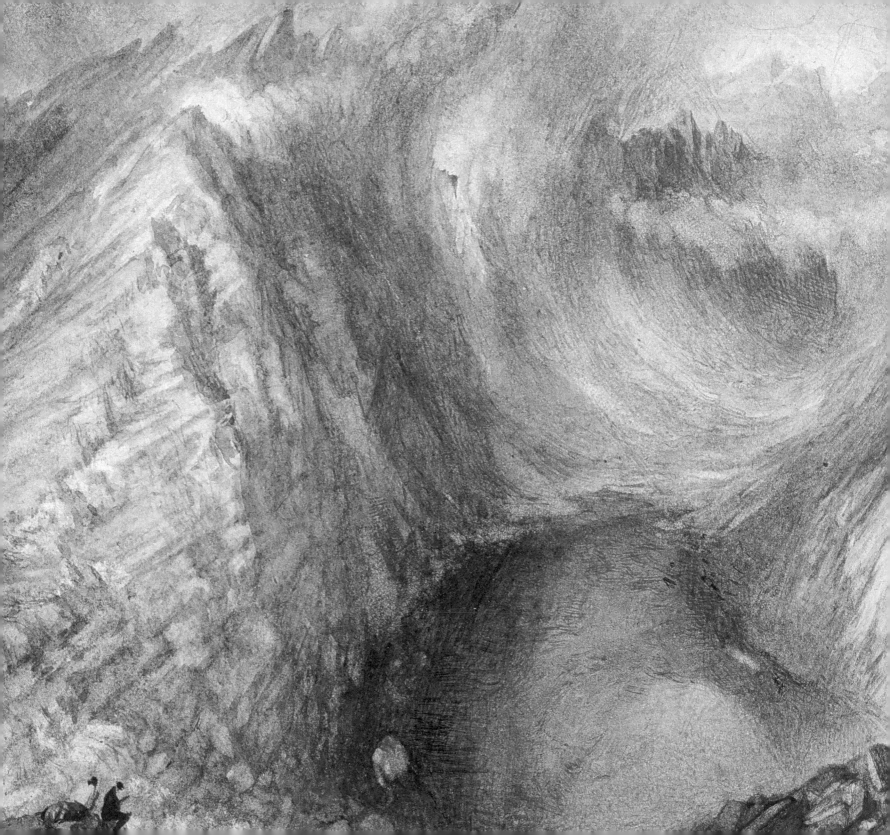

THE VAUGHAN BEQUEST

< Detail from plate 16

1 *Lake Albano*

1794–7 · blue and grey washes over pencil on paper · 42.2 × 54.7cm
D NG 882

Early in his career Turner took advantage of a remarkable opportunity to develop his visual education by studying the collection of the physician Dr Thomas Monro (1759–1833). Monro, who specialised in treating mental illness, worked at Bethlem Hospital in London, where Turner's mother died in 1804, and famously was one of the doctors who treated King George III's bouts of porphyria in 1811–12. However, in the context of British art he is significant for quite different reasons, as he was an amateur draughtsman, a notable collector, and a mentor to a remarkable generation of young painters, including Turner, and his great contemporary, Thomas Girtin (1775–1802). Monro provided them with the opportunity once a week to copy works of art in his collection; he kept the copies and offered as an incentive a modest fee (3s 6d a night) and supper with oysters. Turner attended these evening gatherings at 8 Adelphi Terrace from 1794, when he was nineteen, for about three years, apparently often collaborating with Girtin. A large number of works resulted from this period of study, including *Lake Albano* and four other watercolours which formed part of Henry Vaughan's bequest to Edinburgh. It is difficult, if not impossible, to establish precisely the nature of Turner's contribution to such studies, which for convenience are usually described as 'Monro School' watercolours. Worked up in pale grey and blue washes, they were particularly inspired by the art of John Robert Cozens (1752–1797), who employed such a subtle palette.

Cozens was consigned to Monro's medical care in 1792 and his drawings and watercolours then became available for scrutiny in the doctor's informal 'academy'. They included a number of outstanding works that the artist had produced in Italy in the 1780s, and *Lake Albano* is a copy, in reverse, of a watercolour attributed to Cozens, now in Leeds City Art Gallery, which must have formed part of the Cozens / Monro collection. Studies such as this represent Turner's first engagement with Italian themes, before his travels across Europe, and anticipate the subjects in a number of his later works, many of which were engraved (fig.21).

Lake Albano forms part of the volcanic complex, the Colli Albani, which creates an especially dramatic landscape north of Rome. On the rim of the crater encircling the lake is Castel Gandolfo, the summer residence of the Pope, which is just visible on the horizon towards the left of the composition.

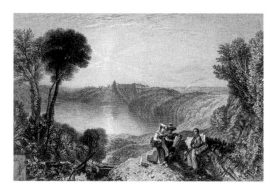

Fig.21 · Robert Wallis (1795–1878) after Turner *Lake Albano*
National Gallery of Scotland, Edinburgh

2 *Rye, Sussex*

1794–7 · blue and grey washes over pencil, with some scraping out on paper · 19.6 × 26.9cm
D NG 853

Rye, which is one of the so-called Cinque Ports, is among the most attractive towns in Sussex. From the sixteenth century onwards, as the sea gradually receded, its strategic and economic importance slowly diminished. Its quay is on the River Tillingham, a tributary of the River Rother, which remains navigable. The town is characterised by timber-framed buildings and fine Georgian architecture, and its skyline is still dominated – just as Turner shows – by the church of St Mary's, which dates from about 1220. The picturesque qualities of Rye had been appreciated by artists since the seventeenth century (notably, Sir Anthony van Dyck made a sequence of five very sensitive drawings of it in 1633).

Turner's study is another example of the drawings made by the young artist when he worked under the patronage of Dr Thomas Monro in the mid-1790s (see plate 1). In this case, however, a specific precedent in the doctor's collection has not been identified.

Turner visited Sussex on a number of later occasions, notably travelling to Petworth, the residence of one of the most important of his landed patrons, Lord Egremont. About fifteen years after working on Vaughan's watercolour he also produced a series of views of the county, as a commission from the local MP, Jack Fuller. The series was eventually published in 1819 as *Views in Sussex* (a set of these prints is in the National Gallery of Scotland's collection). This did not though prove to be a commercial success, and consequently another project, concentrating on Hastings and its vicinity, was abandoned.

Rye came to feature in Turner's work on one final occasion, in 1824, when a highly dramatic view from a distant viewpoint was engraved after one of his watercolours (fig.22). It provides a striking contrast with the serenity of Turner's 'Monro School' work, and shows a rescue from a swell in the foreground.

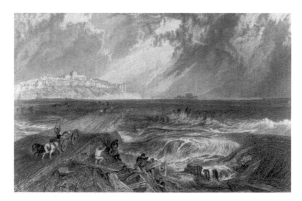

Fig.22 · Edward Goodall (1795–1870) after Turner *Rye, Sussex*
National Gallery of Scotland, Edinburgh

3 *The Medway*

1794–7 · blue and grey washes over pencil, with some scraping out on paper · 20.6 × 29.7cm
D NG 854

The River Medway rises in Sussex and flows for seventy miles through Kent. In Turner's time it was an important transport route – and he hints at such activity with the two sailing barges to the right; such boats were used to carry loads of coal, timber, iron, lime and foodstuffs. However, he is primarily occupied with the visual appeal of the ramshackle wooden building, which may have been part of a boat yard. The wooden posts have a picturesque quality, rather like columns from an ancient ruin.

The Medway is another 'Monro School' work from Vaughan's collection (see plate 1). The early history of such watercolours remains uncertain, although it is likely that all of Vaughan's works of this type came directly from the doctor's collection, which was sold after his death in 1833 at Christie's in London (26–8 June). Monro had acquired quite a large number of oil paintings and watercolours, chiefly by British artists, and kept the copies that had been made by Turner, Girtin and others in his house. The sale catalogue lists over 400 of them.

In 1822 Turner embarked on a publishing project entitled the *Rivers of England*, and over the next three years he produced seventeen compositions for this series, which he eventually abandoned because he fell out with the publisher and engraver William Bernard Cooke. He returned to the subject of the Medway as part of the scheme, and depicted the river at Rochester, thronged with barges, in a work which was engraved in 1824 (fig.23).

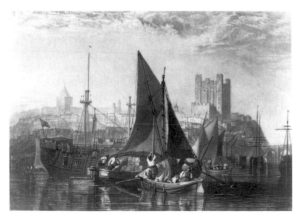

Fig.23 · Thomas Goff Lupton (1791–1873) after Turner
Rochester, on the River Medway
National Gallery of Scotland, Edinburgh

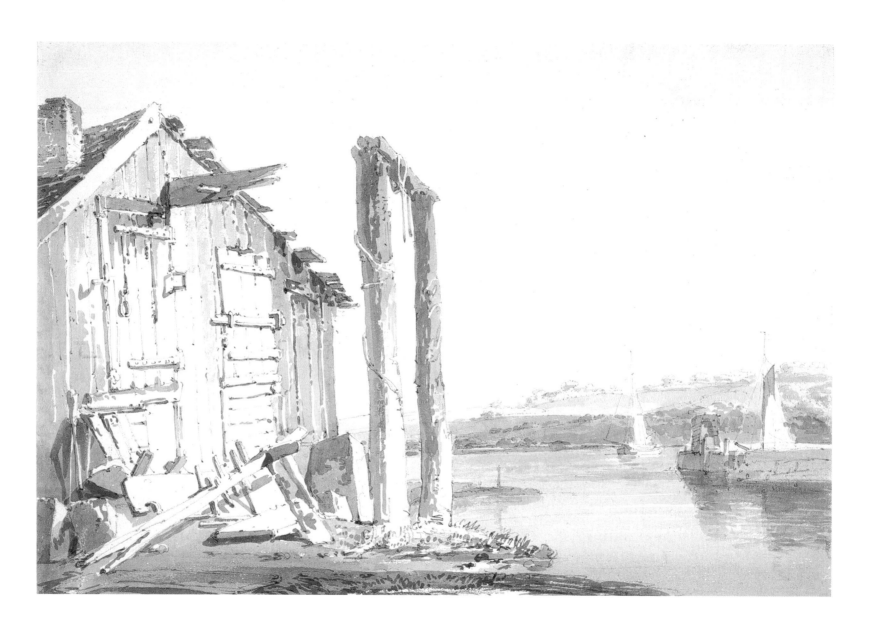

4 *Beachy Head, Looking Towards Newhaven*

1794–7 · blue and grey washes over pencil, with some scraping out on paper · 20.3 × 27.5cm
D NG 855

Beachy Head reaches 162 metres (530 feet) above sea level and is the highest chalk sea cliff in Britain. Here the view to the west is depicted, looking towards Newhaven and Brighton. Turner's study is another 'Monro School' drawing, dating from the mid-1790s (see plate 1).

The artist depicted a number of impressive coastal rock formations early in his career. Another view of a cliff face near Dover formed part of Vaughan's collection and bequest to Dublin (fig.24). Other 'Monro School' works which feature similar scenes include *Cliffs at Dover, Kent* (Whitworth Art Gallery, Manchester) and *Coast View with Chalk Cliffs* (Ashmolean Museum, Oxford). Such studies antici-pate in a restrained manner the mountainous and precipitous landscapes he was to encounter later on

journeys to Wales and Scotland, as well as the interest in geology he was to slowly develop (see plate 16).

Turner was to return to such coastal scenes in 1811 when he started making watercolours for the print series called *Picturesque Views of the Southern Coast of England*. This was the earliest of his commis-sions for major publishing projects and he produced forty designs for the engraver William Bernard Cooke. The project was completed in 1826, and throughout Turner took an intimate interest in controlling the quality of the engravings, recognis-ing that it was through such initiatives that his work would become widely known and more profitable. Two sets of these prints are in the National Gallery of Scotland's collection.

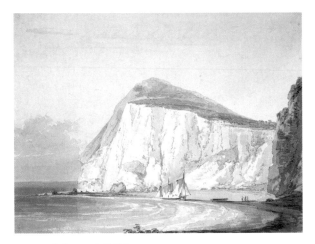

Fig.24 · *Shakespeare's Cliff, Dover*
National Gallery of Ireland, Dublin

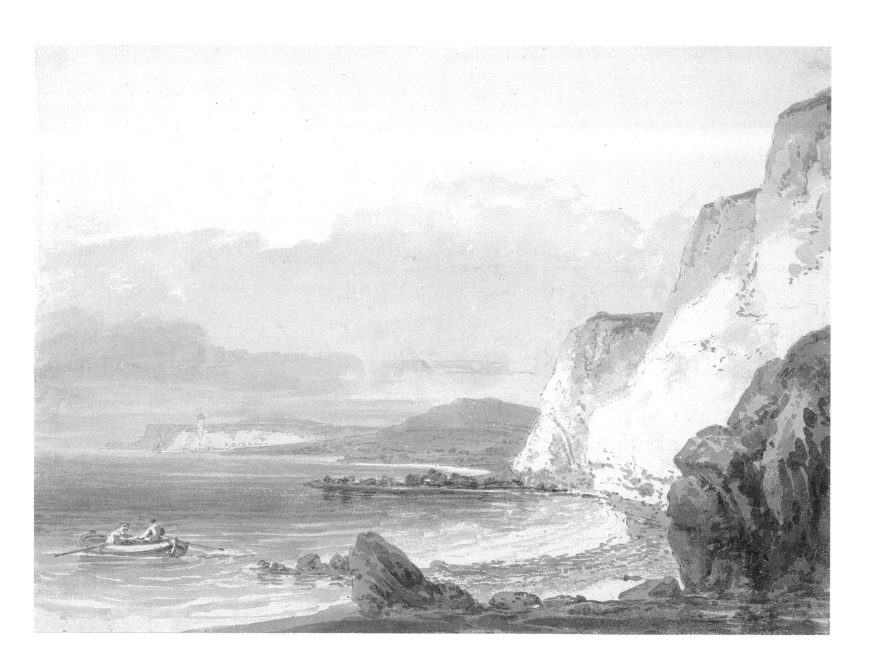

5 *Old Dover Harbour*

1794–7 · blue and grey washes over pencil on paper · 27.2 × 20.9cm
D NG 856

Turner's interest in shipping dated from his experience of the River Thames as a boy, and was sustained throughout his life; he made numerous watercolours and oil paintings of related themes, enjoyed travelling by boat and owned a number of models of ships. Dover and nearby Folkestone clearly provided irresistible subjects for the artist, not only because of the opportunities they afforded for depicting fishing and naval fleets, but also because they represented points of departure for Europe. When Turner undertook his first continental journey in 1802 he sailed from Dover to Calais.

There are nearly one hundred surviving drawings by Turner which are connected with Dover and Folkestone, a number of which, like *Old Dover Harbour,* are 'Monro School' works (see plate 1).

They include two very attractive examples in Vaughan's bequest to the National Gallery of Ireland, which depict Dover's beach and harbour. Many of them show the influence of the watercolours of Edward Dayes (1763–1804), who made very subtle topographical studies, often of British antiquities, which were in Monro's collection and copied by Turner and Girtin.

Dover Castle, seen here on the hill at the right, is a massive fortress, the appearance of which in Turner's day was determined by a building campaign undertaken during King Henry II's reign. It came to feature more prominently in a number of other works by the artist, such as a far more ambitious watercolour of 1822, now in the Museum of Fine Arts, Boston, which was reproduced as a print in 1851 (fig.25).

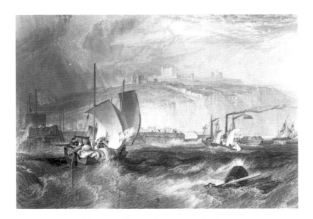

Fig.25· James Tibbitts Willmore (1800–1864) after Turner *Dover*
National Gallery of Scotland, Edinburgh

6 Durham

1801 · watercolour over pencil on paper · 40.9 × 25cm
D NG 889

The city of Durham, which is dominated by its great Norman cathedral, became the subject of Turner's art on three occasions. He first visited County Durham in 1797 and appears to have spent three or four days making a sequence of detailed drawings of the cathedral, castle, old town and River Wear. This work dates, however, from four years later when he was travelling en route to Scotland in 1801 and made some more hurried, summary studies. Turner was later to return to the subject in the mid-1830s, creating one of the greatest of all his mature watercolours (plate 18).

The cathedral is viewed here from the north, as the sun is rising; the forms of the architecture and dramatic background are simplified, and the artist has adopted a rather dour palette, primarily ranging across greys and browns to acidic yellow in the foreground. He has moved far beyond the conventions employed in the 'Monro School' watercolours, and can be seen to be developing his own highly original response to directly studied atmospheric effects.

Turner would have travelled from London to Scotland by mail coach, and had he not broken his journey, the whole trip might have taken about sixty hours. On his arrival in Edinburgh, he used paper almost certainly from the same sketchbook employed for his study of Durham, to depict some fine views of the city, including one now in the National Gallery of Ireland (fig.26). This work also came from Vaughan's collection, but why he decided to bequeath it to Dublin, rather than Edinburgh, remains unclear.

Fig.26 · *Edinburgh from Salisbury Crags*
National Gallery of Ireland, Dublin

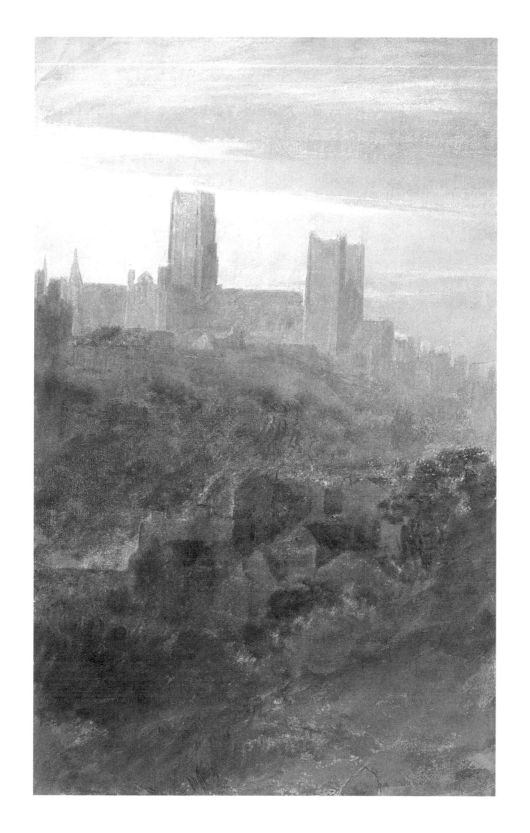

7 *The Falls of Clyde*

1801 · watercolour over pencil, with some scraping out on two sheets of paper joined and laid down · 41.3 × 52.1cm
D NG 886

During his 1801 Scottish tour, after staying in Edinburgh, Turner travelled to Linlithgow, Glasgow, Loch Awe, Loch Tay, Blair Atholl, Stirling and Hamilton, before visiting the Falls of Clyde; he then continued back into England via Gretna Green. The falls had become renowned as a natural wonder which attracted artists and writers since the mid-eighteenth century, when Paul Sandby (1730/1 – 1809) first depicted them. Other enthusiastic visitors included William and Dorothy Wordsworth and Samuel Taylor Coleridge.

This is the first of Turner's watercolours of the falls, and he has sketched Corra Linn ('linn' is Scottish for waterfall), the lowest, but perhaps most dramatic of them, from the river's edge. At this time, permission from local landowners was required to visit the site, along with the services of a guide; it was only in the 1850s that nearby Lanark was opened up to tourism with the arrival of the Caledonian Railway.

The drama of the torrent thundering through a narrow chasm evidently appealed to Turner as he was to develop the subject further, gradually overlaying his later depictions with imaginative additions. Back in London in 1802 he exhibited a watercolour at the Royal Academy which showed the falls with bathing nymphs in the foreground, so referring to a poem by Mark Akenside published in 1746 (fig.27); this work was then used as the basis for a print of 1809 in his *Liber Studiorum*. Finally, in the 1840s, Turner created an oil painting of the falls in which all the elements – water, rock and light are fused in a golden visionary scene (Lady Lever Art Gallery, Port Sunlight).

Other studies connected with his 1801 visit are in the Fogg Art Museum, Harvard, and the Indianapolis Museum of Art.

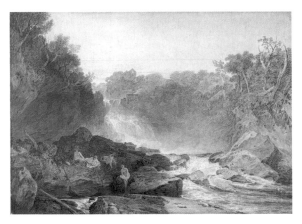

Fig.27 · *The Fall of Clyde, Lanarkshire: Noon –
Vide Akenside's Hymn to the Naiads*
The Walker Art Gallery, National Museums Liverpool

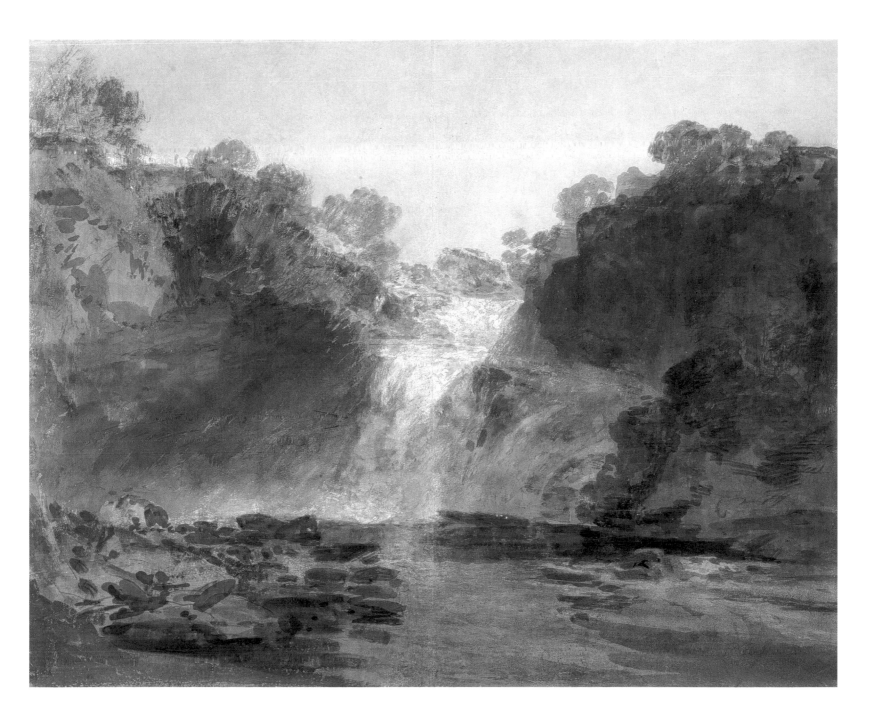

8 *Neuwied and Weissenthurm, on the Rhine, Looking Towards Andernach*

1817–19 · watercolour and pen and ink and gum, with scraping out on paper · 18.6 × 28.8cm
D NG 857

Turner was an indefatigable traveller and first visited Europe during the Peace of Amiens in 1802. His next extended tour was undertaken fifteen years later after the end of the Napoleonic Wars, in August and September 1817; from then on almost every summer for the rest of his life he crossed the Channel. The 1817 journey included tours of Belgium and the Rhineland and featured a visit to the field of Waterloo, as well as an exploration of the Rhine as far as Mainz.

Roughly halfway between Linz and Coblenz on the Rhine are the towns of Neuwied and Weissenthurm; located on the north and south banks of the river respectively, they are depicted to the right and left in this view. Weissenthurm is named after its monumental white tower, which Turner depicts in shadow. The river continues its course through the blue hills at the centre of the composition, and on towards Andernach.

Turner travelled along the banks of the Rhine on foot making numerous studies in pencil, and filling four sketchbooks. The one related to this scene was later worked up into a watercolour, now belonging to Winchester College; Turner then took up the composition again two years later and created Vaughan's watercolour which is more elaborate and highly finished. He took particular care over the depiction of the barges, and details such as the hunter with his spaniel and the birds skimming the surface of the water in the foreground.

In 1819 Turner signed a contract with the printmaker William Bernard Cooke to provide watercolours that would be engraved in a book of Rhine views to be published by Cooke and John Murray (1778–1843). The artist worked up three watercolours connected with it – Vaughan's work, and depictions of *Ehrenbreitstein* (Bury Art Gallery and Museum), and *Osterspey and Feltzen* (Museum of Art, Rhode Island School of Design, Providence). The project was, however, never completed; it failed because of the publication in 1819–20 of an English version of a tour of the Rhine that had earlier appeared in Germany. Innovation was vital in the precarious world of publishing that Turner depended on to expand his reputation.

The artist did, however, work with Cooke on a number of other projects which proved successful, including *Rivers of England* (1823–7) (see plate 3) and *Marine Views* (1824–5). From 1822 to 1824 Cooke also organised annual loan exhibitions of drawings, chiefly by Turner, and promoted and sold the artist's *Liber Studiorum*.

9 *Man of War*

1827 · pencil on paper · 16.1 × 22.6cm
D NG 852

This very confident pencil study is one of four drawings of shipping made by Turner in the summer of 1827, while he was visiting East Cowes on the Isle of Wight. He has suggested with remarkable brevity the complexities of the ship's rigging, the reflections in the still water, and anecdotal details, such as the large bonnets worn by the women sitting in the stern of the rowing boat at the right. Turner first visited the island in 1795; he returned in 1827 in order to depict East Cowes Castle, overlooking the Solent, which was the home of his friend, the neoclassical architect and urban planner, John Nash. Turner remained as Nash's guest for about six weeks, from late July to early September. It appears to have been a particularly enjoyable and productive stay, with the attraction of a regatta to watch. He painted two oil paintings of the regatta and Nash's home, which were exhibited at the Royal Academy the following year.

Another drawing from this Isle of Wight group also belonged to Henry Vaughan and formed part of his bequest to Dublin (fig.28). It appears to show the same Man of War, but in full sail and on a choppy sea. The two remaining related studies are in a private collection. All four, unusually for works of this type, are prominently signed by Turner; this is explained by a letter that survives with the private collection sketches stating that they were made for Harriet Petrie (1784–1849) who was visiting Nash at the time of Turner's stay; it appears, therefore, that the artist thought it appropriate to sign such presentation pieces. It was only from 1802 onwards, after he had been elected a full member of the Royal Academy, that he adopted the formula 'JMW Turner' for his signature. Previously he had styled himself simply 'William Turner'.

All of the 1827 drawings may be loosely connected with the preparations Turner was making for his *Ports of England* series of prints (1823–8). This project was originally intended to consist of twenty-five mezzotints, but Turner quarrelled with his engraver, Thomas Goff Lupton, and only six of the prints were published in his lifetime. Later, in 1856, they were re-issued with six additional views and given the title *The Harbours of England*.

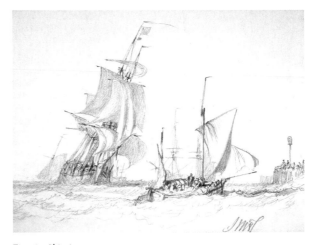

Fig.28 · *Shipping*
National Gallery of Ireland, Dublin

10 *Harbour View*

Mid-1820s? · watercolour and gouache on blue paper · 13.9 × 18.9cm
D NG 880

This is an intense study in colour relationships rather than precise topography, and it is unlikely that the site will ever be identified with certainty. It is possible, however, that it represents a harbour such as the one at Margate on the Kent coast. Turner regularly visited this seaside town, which was one of the most convenient resorts near London before the development of the railway network. Fishermen appear to have gathered in the foreground and are perhaps depicted repairing nets, while part of their catch has been laid out at the left. Turner himself enjoyed fishing, and later made some superb individual watercolour studies of fish.

It was from the mid-1820s, the period to which this work probably dates, that Turner started to use blue paper for watercolour and gouache studies. Gouache is watercolour which has had white pigment added to it to make it opaque; it is notably used here in the foreground for the highlights on the figures. Turner continued to buy blue paper until the late 1830s (see plates 12, 25), and fully exploited the hue, tone and texture of such sheets when developing his compositions. The artist is known to have favoured a particular supplier of such paper – George Steart of Bath, who produced blue, grey and buff papers, which were carefully finished so that that they provided a durable surface for amateur or professional artists to work on.

11 *Sea View*

Mid-1820s? · watercolour and gouache on blue paper · 13.5 × 19cm
D NG 881

This is one of the most sensuous of Vaughan's
Turners; a superbly preserved seascape, it appears to
show the sails of boats suggested in the foreground.
The daring nature of the artist's palette, as explored
in such works, is a quality of his watercolours to
which John Ruskin, the artist's most eloquent
champion, was especially sensitive. Ruskin wrote in
the fifth volume of his *Modern Painters*:

> … *the peculiar innovation of Turner was the perfection of
> the colour chord … Other painters had rendered the golden
> tones, and the blue tones, of the sky; Titian especially the
> last in perfectness. But none had dared to paint, none seem
> to have seen … the purple …*

Vaughan's study probably dates from the mid-1820s,
and is contemporary with the artist's *Harbour View*
(plate 10); it is likely that he acquired them both
from the same source.

12 *Lake Como Looking Towards Lecco*

c.1828 · watercolour and gouache and black chalk on blue paper · 14.2 × 18.8cm
D NG 878

Lake Como, one of the most spectacular of the north Italian lakes, is set amid splendid alpine scenery. The small town of Lecco is located at the southern extremity of the eastern branch of the lake. Turner first visited Como in 1819, and he included a depiction of the lake among his vignettes illustrating the long poem *Italy* by Samuel Rogers (1763–1855). These illustrations, which he worked on in 1826–7, were published in 1830, and proved extraordinarily successful (fig.29).

This watercolour, which includes a slight study of a horse-drawn carriage in the foreground, appears to show a view similar to that seen at the centre of the vignette, with a promontory and tower, and it is possible that it was used as part of the preparation for it. Alternatively, it may be an independent work connected with the journey that Turner made to Italy in 1828; in August of that year the artist visited Rome, travelling via Paris, Lyon, Avignon and Florence. Such a dating has to remain tentative, however, as no associated drawing has been identified in the artist's sketchbooks.

Turner was to visit Lake Como again, in the early 1840s. Crossing the lake on a steamer, he was observed by the photographer and painter William Lake Price (1810–1896), who noted a valuable description of Turner's working methods, which was published in *Photographic News* in 1860:

Turner held in his hand a tiny book, some two or three inches square, in which he continuously and rapidly noted down one after another of the changing combinations of mountain, water, trees etc. until some 'twenty' or more had been stored away in the hour-and-a-half's passage.

Fig.29 · Edward Goodall (1795–1870) after Turner *Como*
National Gallery of Scotland, Edinburgh

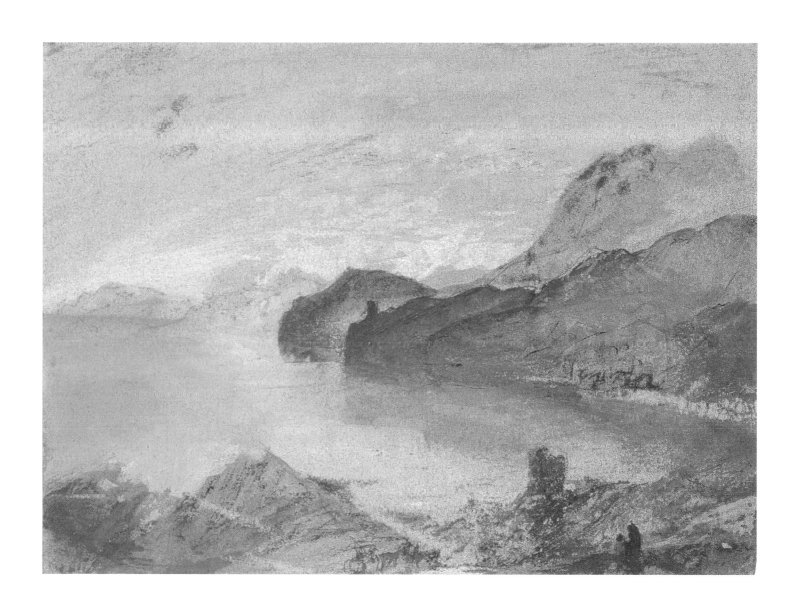

13 *Rhymer's Glen, Abbotsford*

1831–2 · watercolour and pen and ink over pencil, with scraping out on paper · 14 × 9cm
D NG 858

Turner was profoundly inspired by the landscapes of Scotland, and avidly read the work of the great romantic poet, novelist and historian Sir Walter Scott (1771–1832), whose infectious passion for Scottish culture informed all his writing. John Ruskin described the two men as 'the principal types … of the age … both *seers* rather than thinkers', and it is perhaps unsurprising that they came to collaborate. They first made contact in 1818, when Turner began working on watercolours to illustrate Scott's *The Provincial Antiquities and Picturesque Scenery of Scotland* (1818–26). They met again in 1822 when Turner witnessed the arrival of King George IV in Edinburgh, and all the attendant ceremonial which was stage-managed by Scott. Turner was then employed to illustrate editions of Scott's poetical and prose works, and in 1831 he stayed with Scott at his country house, Abbotsford. Initially, Scott does not appear to have had a very high opinion of Turner, because of his preoccupation with money, but by 1831 they had developed an altogether more sympathetic relationship.

Abbotsford is in the Borders near Melrose on the River Tweed. By the time of Turner's stay, Scott had converted it from what had originally been a modest farmhouse into an imposing gothicised, baronial home, filled with casts and relics relating to Scottish history. Turner visited the Borders from 4 to 11 August 1831, spending five days with his host. He made sketches of the house and grounds, including studies of Rhymer's Glen, an area of woodland by a series of waterfalls at Huntly Bank on the

Abbotsford estate, which was apparently Scott's favourite spot for composition and contemplation. At this period Turner was preparing to illustrate Robert Cadell's edition of the *Miscellaneous Prose Works of Sir Walter Scott,* and Cadell noted the artist's visit in his diary (National Library of Scotland). He described Turner's determination to sketch in the glen with Scott's daughters after dinner on 7 August.

Sir Walter Scott died on 21 September 1832. Turner's watercolour, which was based on his initial pencil sketches made a year earlier, was developed to take the form of a posthumous tribute to Scott's work, and perhaps the impact it had on Turner's own. The artist has depicted Scott's walking stick on the wooden bench beside the stream, so subtly implying both his presence and absence. The watercolour was engraved, and in 1835 used as the title-page vignette for volume twenty-one of the *Miscellaneous Prose Works,* which included his critical writings on landscape gardening. The whole publication ran to twenty-eight volumes, which were published monthly between May 1834 and August 1836.

14 *Chiefswood Cottage, Abbotsford*

1831–2 · watercolour and pen and ink over pencil on paper · 15 × 10cm
D NG 859

Chiefswood Cottage, on the Abbotsford estate, was the summer home of Sir Walter Scott's daughter, Charlotte Sophia (1799–1837), and her husband John Gibson Lockhart (1794–1854) (fig.30). Lockhart, who was a reviewer and essayist, met Scott in 1818; they became close friends and in 1820 he married Scott's eldest daughter. The couple enjoyed a happy life together and they provided support for Scott, especially after he became insolvent in 1826. All the proceeds from Lockhart's *The Life of Sir Walter Scott* (1836–8) were used to pay off the writer's creditors. This publication was illustrated with two vignettes by Turner – one of which showed Scott's townhouse at 39 Castle Street, Edinburgh.

In *Chiefswood Cottage*, Turner has placed a chair in the shade, and a desk with an inkwell and stool in the sunshine; both are unoccupied. They must refer to the writing of Scott, rather than his son-in-law, and convey the same sense of loss and poignancy that is the dominant quality of *Rhymer's Glen*. The pencil studies used as the basis for both works survive in the sketchbook that Turner used in 1831 at Abbotsford (now in Tate Britain). *Chiefswood Cottage* was engraved as the title page vignette for volume twenty-eight of the *Miscellaneous Prose Works of Sir Walter Scott*, Edinburgh (1834–6).

The creation of such vignettes formed a significant aspect of Turner's career. Essentially miniatures, the edges of which dissolve into the surrounding page, they formed a very powerful and evocative form of book illustration. Turner excelled at designing them, often compressing a remarkable range of incidents and landscapes into such a small space, which had to be matched by the skill of the engraver. He designed nearly 150 vignettes that illustrated the work of historical authors, such as John Milton and John Bunyan, as well as contemporaries, who included along with Scott, Samuel Rogers, Lord Byron and Thomas Campbell. The National Gallery of Scotland's collection includes the only complete set of Turner's vignettes to remain together – those he created for Campbell's *Poems* (see fig.38).

Fig.30 · Robert Scott Lauder (1803–1869)
John Gibson Lockhart and Sophia Scott
Scottish National Portrait Gallery, Edinburgh

15 *Melrose*

1831–2 · watercolour, with scraping out on paper · 10 × 15.6cm
D NG 860

Melrose is situated in the Tweed Valley in the Borders, at the foot of the peaks of the Eildon Hills. Its ruined twelfth-century abbey, which Turner depicts just to the left of the centre of his composition, was once among the richest in Scotland. The artist shows a view from a splendid vantage point above the Tweed, with the evening sun, low in the sky, above the town's chain bridge, which was built in 1826. At the edge of the broad expanse of the river, cattle have come to drink at the end of the day.

Sir Walter Scott's estate, Abbotsford, is three miles west of Melrose. During Turner's stay with the writer in August 1831 two expeditions were made which included stops at this spot. The first was on 6 August when the publisher Cadell (who recorded the event in his diary), along with Turner, Scott and his servant, James, stopped to admire the view; they were travelling to and from nearby Smailholm Tower, a landmark Scott knew intimately, as he had been brought up in Sandyknowe farmhouse beside it. During the second visit, on the following Monday, the party – which did not include Scott – picnicked on the hillside, and Turner sketched his companions. This watercolour clearly shows the picnic, and Turner appears to have depicted himself drawing beside an upturned parasol (fig.31).

Cadell noted that Scott had asked Turner to choose an illustration to use as the frontispiece for his *The Lay of the Last Minstrel*, and the artist suggested his study of Melrose. It was engraved by William Miller (1796–1882) in 1833 and became the frontis-piece for the poem in volume six of Sir Walter Scott's *Poetical Works* (1834).

The watercolour was based on pencil sketches in Turner's so-called *'Abbotsford'* sketchbook (Tate Britain), which was used by the artist in August 1831. The studies he made in it also provided material for other vignettes; these include a work, in a private collection, which shows Scott, Turner and their companions travelling in an open coach away from Smailholm Tower and Sandyknowe farmhouse. This watercolour was not intended as the basis for an engraving, but was made by Turner as a personal souvenir for Scott. Turner sent it to Scott in Naples in March 1832, when Scott was suffering from his final illness. Scott died six months later, and was buried at Dryburgh Abbey by St Boswells, near Melrose.

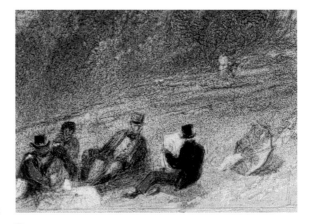

Fig.31

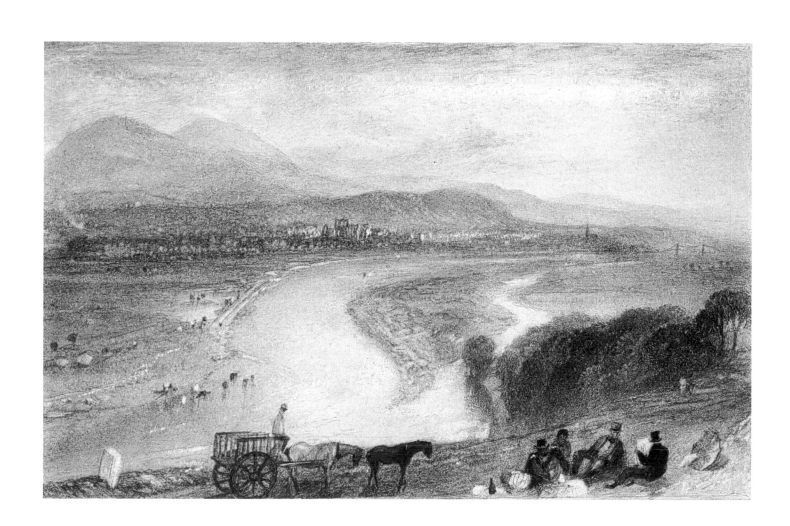

16 *Loch Coruisk, Skye*

1831–4 · watercolour, with scraping out on paper · 8.9 × 14.3cm
D NG 861

Turner left the Borders on his 1831 tour of Scotland and then embarked on a journey to the Highlands, travelling alone. He discussed with the publisher Cadell a list of suitable subjects he might work up to illustrate Sir Walter Scott's *The Lady of the Lake* and *The Lord of the Isles*, and decided to travel as far as Fingal's Cave on Staffa, and the remote Loch Coriskin (Coruisk) amid the Cuillins on the Isle of Skye.

On reaching the loch, Turner made a number of brief pencil sketches from the precipitous slopes surrounding it, but none of them precisely relates to this spectacular watercolour, which must have been composed slightly later. It was engraved in 1834 by Henry Le Keux, as the frontispiece to volume ten of Robert Cadell's edition of Scott's *Poetical Works,* which contained the author's *The Lord of the Isles.*

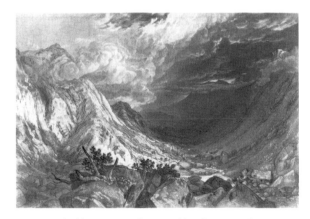

Fig.32 · Etched by Turner and engraved by Thomas Goff Lupton (1791–1873) *Ben Arthur, Scotland*
National Gallery of Scotland, Edinburgh

Turner conceived the scene as two vortices in which the rocks and turbulent weather appear to fuse; similar compositional ideas can be seen, although less fully developed, in the artist's 1819 depiction of *Ben Arthur* which formed part of his *Liber Studiorum* series of prints (fig.32). It has been suggested that Turner may also have drawn at least part of his inspiration for *Loch Coruisk* from the work of the Scottish descriptive geologist John Macculloch (1773–1835). Turner could have met Macculloch as early as 1814, and acquired from him volumes of *The Transactions of The Geological Society*. Mucculloch, who was reported to be 'delighted with [Turner's] acute mind', published his *Highlands and Western Isles of Scotland* in four volumes in 1824. It took the form of a series of letters to Sir Walter Scott, whom he had known since the 1790s, and included very powerful, evocative descriptions of sites that Turner was to visit. According to Macculloch, when he saw the loch:

I felt as if transported by some magician into the enchanted wilds of an Arabian tale, carried to the habitation of the Genii... I felt like an insect amidst the gigantic scenery, and the whole magnitude of the place became at once sensible.

Turner has placed tiny insect-like figures, perhaps including himself, in the foreground, so establishing a sense of scale and awe.

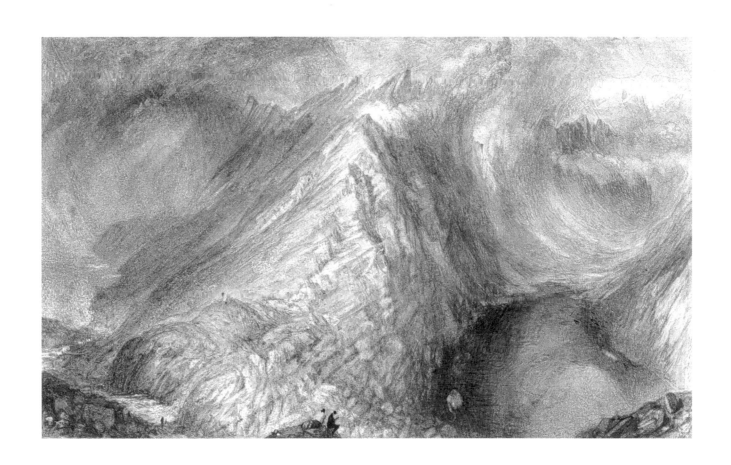

17 *Llanberis Lake and Snowdon, Caernarvon, Wales*

*c.*1832 · watercolour and gouache and pen and ink on paper · 31.8 × 47.1cm
D NG 884

Turner toured Wales four times in the 1790s and his experience of its mountainous scenery constituted an important stage in his exploration of awe-inspiring landscapes, before his discovery of the Scottish Highlands and the Alps. He built up a repertoire of many drawings during this period which he later referred back to. This magnificent watercolour, dating from about 1832, is based on sketches in his so-called *'Dolbardon'* sketchbook of 1799 (Tate Britain).

Although it is ostensibly a depiction of the highest mountain in Wales and the nearby pictur-esque lake, with the ruin of Dolbardon castle at its edge, Turner is not concerned here with topographi-cal precision. He depicts shafts of light descending from the upper right, as though using the landscape like a giant prism to view a spectrum of shifting colours: reds, golds and blues. Scale and anecdotal interest are provided by the men engaged in fly fishing and the mother nursing a small child who watches them. Turner himself loved fishing and considered it an especially conducive form of relaxation, which he could combine with painting or writing poetry.

Llanberis Lake and Snowdon and the contemporary watercolour of *Durham*, also in Vaughan's collection, were commissioned by the printmaker Charles Heath (1785–1848) for the ambitious series of prints *Picturesque Views in England and Wales*. Heath was one of the finest engravers of the early nineteenth century. He worked on a number of publications to which Turner contributed, and his most extensive

and complex project was the *Picturesque Views* series, produced between 1827 and 1838. It was originally intended to consist of twenty-four parts containing 120 engravings based on Turner watercolours. *Llanberis Lake and Snowdon* was engraved by J. T. Willmore and published in 1834 as number three in part VIII of *Picturesque Views*. However, the project had a troubled history and proved a commercial failure; only ninety-six plates were eventually produced, and the scheme bankrupted Heath.

John Ruskin, who believed that close scrutiny of details of geology could reveal all the complexities of nature, made a copy in watercolour of the rock in the centre foreground of *Llanberis Lake and Snowdon* (fig.33). It was engraved for the fifth volume of his *Modern Painters* (1860). As Turner's work had been acquired by Vaughan in 1854 it may well have been studied by Ruskin when in his collection.

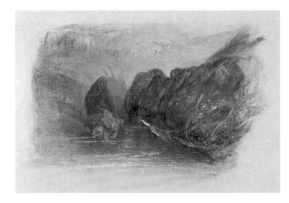

Fig.33 · John Ruskin (1819 –1900) after Turner *Rocks*
National Gallery of Scotland, Edinburgh

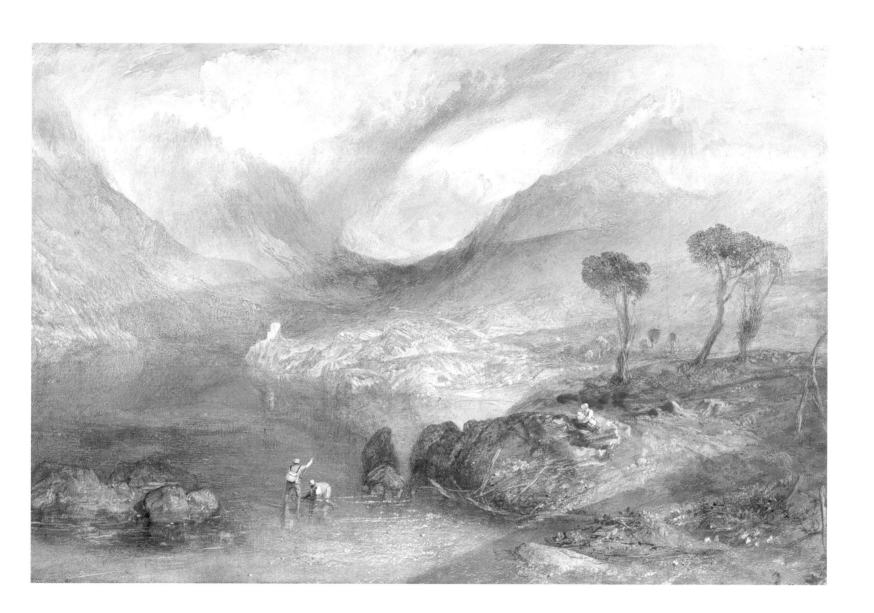

18 *Durham*

c.1835 · watercolour and gouache and gum, with scraping out on paper · 29.5 × 44cm
D NG 883

This dream-like view of Durham, seen from the Prebends' bridge, provides a dramatic contrast with Turner's earlier and altogether more earthy study of it made in 1801 (plate 6), which was also in Vaughan's collection. Here the artist has used conventions of composition and lighting found in the work of the great seventeenth-century landscape painter Claude Lorrain to enrich his vision. Of all the old master painters Turner admired, Claude became the most influential. He had numerous opportunities to study Claude's works as many of them were in British collections by the early nineteenth century, having been avidly acquired by Grand Tourists. Turner's respect for Claude was essentially based on the fact that he shared the earlier artist's ambition to explore fully the myriad poetic possibilities of landscape as a serious subject for art. In one of his 1811 lectures on perspective delivered at the Royal Academy he described Claude's work as 'calm, beautiful and serene'. The golden light and setting sun, as well as the composition of this watercolour, in which the city is carefully 'framed' with the trees at the left and parapet at the right, all allude to the precedent of Claude; as a result a city in northern England is almost transformed into one of his Mediterranean seaports.

Turner employed poetic licence to suit his purpose; he turned the cathedral forty-five degrees from its true position so that it faces the viewer more emphatically. He also extensively worked with great precision this part of his composition, carefully incising the paper, with a needle or very sharp knife, to define the architectural details (fig.34). The artist also took particular care over the print made from *Durham*, which was engraved by the Scot William Miller (1796–1882) in 1836, and published as number one in part XXIII of *Picturesque Views in England and Wales*, (see plate 17).

Henry Vaughan must have fully understood Turner's respect for Claude: he owned one of Claude's drawings (see fig.7) and valued highly the artist's *Liber Studiorum* prints – arguably Turner's most sustained homage to his predecessor.

Fig.34

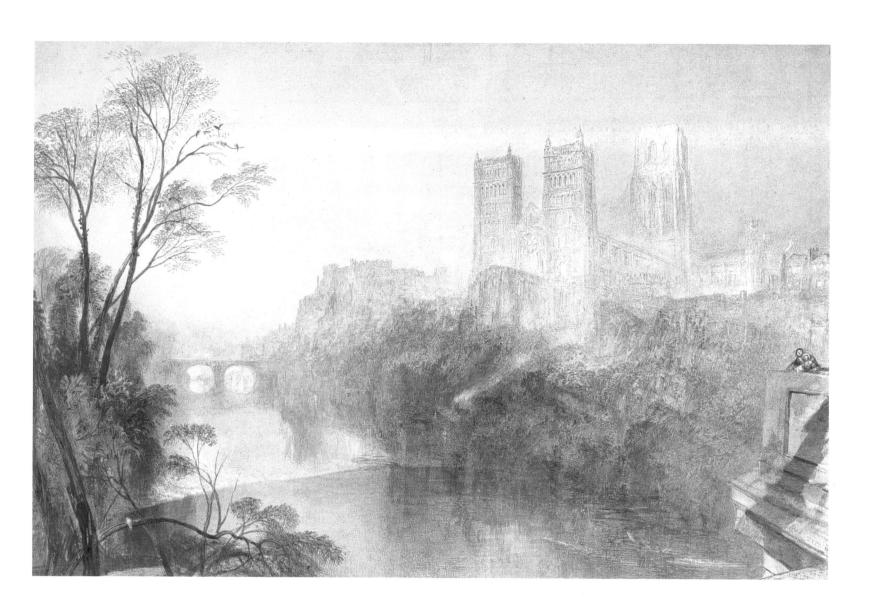

19 *Falls Near the Source of the Jumna in the Himalayas*

*c.*1835 · watercolour, with scraping out on paper · 13.6 × 20.2cm
D NG 862

Turner never travelled beyond Europe, but this did not prevent him from using the works of other artists as the inspiration for depictions of exotic scenes; he painted landscapes from the Holy Land to the Andes, and was twice attracted to subjects from India. He first treated such scenes in about 1800 when he made three views of Seringapatam which are thought to have been based on drawings by Thomas Sydenham. However, this view of the Himalayas comes from his second engagement with Indian subjects: it is one of seven works by him, executed in about 1835, which were based on sketches by Lieutenant George Francis White of the 31st Regiment, and engraved for *White's Views of India, chiefly among the Himalaya Mountains*. White's work was published by Henry Fisher in monthly parts in 1836, and then issued as a book with text by

Emma Roberts in 1838. Other artists who contributed to the publication included Clarkson Stanfield and David Roberts. Two prints from the *Views of India* are in the collection of the National Gallery of Scotland (fig.35).

Turner must have been aware that there was a receptive audience for such imagery in Britain: 'armchair travellers' were keen to discover – even if only at second hand – the visual appeal of foreign cultures and landscapes. The Himalayas represented perhaps the least well known aspect of India from the British perspective and the first extensive pictorial record of them was published only in 1802 by the Scottish explorer James Baillie Fraser (1883–1856); in 1815 he undertook a pioneering journey to locate the source of Jumna – the subject of Turner's watercolour.

The Jumna or Yamuna river rises in the Himalayas and flows for 1,370 kilometres in a south-easterly direction past Delhi to the Ganges. It was an important artery for trade and is now primarily a source of irrigation. Turner has placed a tent with two figures in the foreground, and at the left appears to show an artist at work, studying the overwhelming landscape.

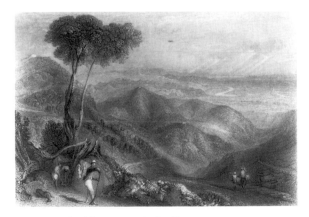

Fig.35 · W. Floyd (active 1830s) after Turner
Valley of the Dhoon, Himalaya Mountains
National Gallery of Scotland, Edinburgh

20 *Sion, Capital of the Canton Valais*

*c.*1836 · watercolour and gouache on paper · 24.1 × 30cm
D NG 864

On 30 September 1802 Turner met the artist and diarist Joseph Farington in the Musée du Louvre. Farington noted Turner's description of Switzerland, which he had just visited for the first time:

He thought the lines of the landscape features rather broken … but there are very many fine parts – fragments and precipices very romantic and strikingly grand … The Country on the whole surpasses Wales and Scotland too.

These impressions mark the beginning of Turner's appreciation of the splendour of alpine landscapes, which was to be sustained through much of the rest of his life. Turner returned to Switzerland in 1836, 1841, 1842, 1843 and 1844.

It is likely that this work dates from the 1836 tour, undertaken when Turner was aged sixty-one, with the Scottish landowner Hugh Munro of Novar (1797–1864). Munro was an amateur painter and major collector of old master and British paintings. He was in touch with Turner by 1826 and built up a substantial collection of his watercolours and oils: the latter included two views of Rome (collection of the Earl of Rosebery, on loan to the National Gallery of Scotland) and *Modern Italy – the Pifferari* (Kelvingrove Art Gallery and Museum, Glasgow). His collection was dispersed in a series of sales from 1867 to 1880.

Turner visited Munro's home in Scotland in 1831 and it is clear that they became friends. The artist suggested that Munro join him on a European sketching tour and they departed from Dover in the late summer of 1836. The two men visited Arras, Rheims, Chaumont, Dijon, Geneva, Bonnevile and Chamonix before travelling on to the Val d'Aosta and Turin. Turner made a large number of watercolour studies during their alpine explorations and Munro tried to buy them from him at the end of the journey, but Turner refused to part with them – presumably because he felt they might inspire later works.

Sion is the capital of the Canton Valais and is dominated by two hills which rise from the flat floor of the valley, each of which is surmounted by a medieval castle. This watercolour probably shows a view from the neighbouring village of Ardon to the south-west. Sion's cathedral can be seen to the left.

21 *Sion, Rhône*

*c.*1836 · watercolour, with scraping out on paper · 24.5 × 27.7cm
D NG 876

It is likely that this study dates from Turner's 1836 journey to Switzerland during which he painted *Sion, Capital of the Canton Valais* (plate 20). It is thought to show another view of Sion, from the south-east. The broad washes of colour which exquisitely define the form of the mountain and golden sky may well have been applied by Turner while sitting before the landscape, rather than as a later recollection based on pencil sketches made outdoors. Munro, who travelled with the artist in 1836 recalled that:

All along … whenever he could get a few minutes, he had his little sketchbook out … I don't remember colour coming out until we got into Switzerland …

During this tour, Munro was also clearly learning from Turner about the subtleties of using colour. He recounted an anecdote to John Ruskin which the critic later used in his *Modern Painters*, according to which he was having problems over a coloured sketch and Turner used the pretence of trying some different paper to illustrate a solution:

… he disappeared for an hour and a half. Returning he threw the book down … There were three sketches on it, in three distinct states of progress of colouring from beginning to end … clearing up every difficulty which his friend had got into …

This watercolour can perhaps be considered one of Turner's colour 'Beginnings' – a word he had earlier coined himself for works in which he very broadly defined the hues and structure of a composition.

22 *Monte Rosa (?)*

1836? · watercolour on paper · 24.3 × 33.9cm
D NG 887

This study is probably another work from Turner's 1836 Swiss tour. The location has not been precisely identified; it is possibly, however, a view of part of Monte Rosa, a mountain massif or complex in the Valais Canton of Switzerland which extends into the Italian regions of Piedmont and the Aosta Valley, and includes the Matterhorn. The artist has employed a very subtle palette, with purple and rose-coloured washes to define the mountains themselves, while the foreground is brought into sharper focus with the use of dark greens and acidic yellow – a device he used earlier, for example, in the first of his two depictions of Durham in the Vaughan collection (plate 6).

In such works, Turner was undoubtedly concerned not only with depicting precipitous rock faces and glacial valleys, but also a sense of the claustrophobia that can be experienced in such a region, which is conveyed by the fact that so little of the view is given over to sky. He created similar effects in other watercolours from this tour, including one in Vaughan's bequest to the National Gallery of Ireland (fig.36). Both of these studies were almost certainly made from spots only accessible by foot.

The discovery of the Swiss Alps by English artists was a phenomenon which dated from the mid-eighteenth century: artists such as William Pars (1742–1782) made fairly extensive tours (his was undertaken in 1770). It was, however, only in the early nineteenth century that painters – and Turner was a key pioneer in this respect – became more adventurous in their explorations. He brought to such studies an informality, chromatic brilliance and poetic sensibility that was unprecedented.

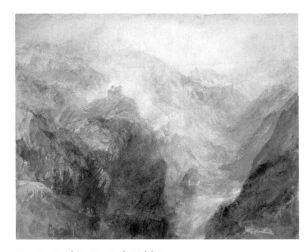

Fig.36 · *An Alpine Pass in the Val d'Aosta*
National Gallery of Ireland, Dublin

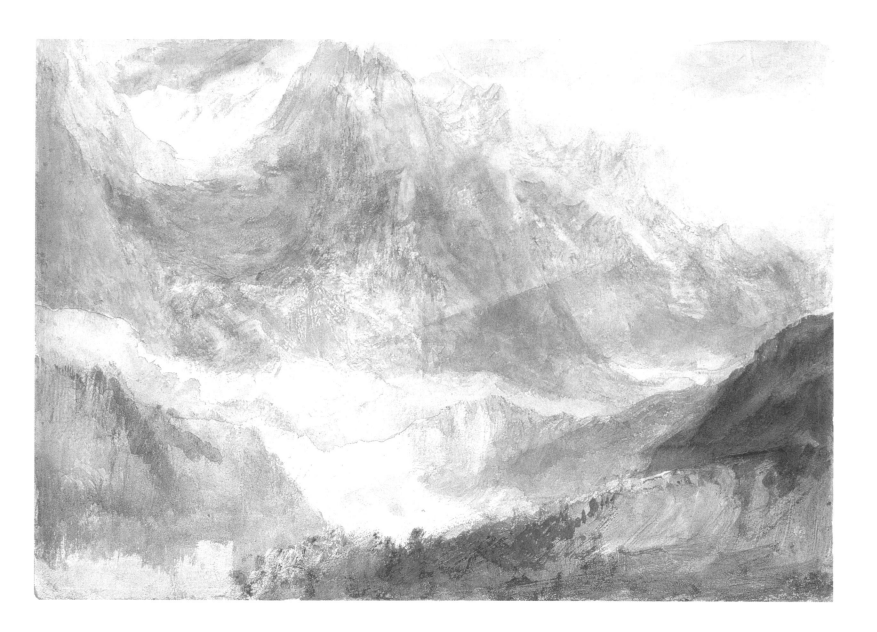

23 *Châtel Argent, in the Val d'Aosta, near Villeneuve*

1836 · watercolour and gouache, with scraping out on paper · 24 × 30.2cm
D NG 870

Châtel Argent is another example of the watercolours Turner created during his 1836 Swiss tour with Munro of Novar. It can be connected with some of the sketches in the artist's so-called *'Fort Bard'* sketchbook (Tate Britain), which was used during this journey. Vaughan owned seven watercolours from this period, four of which are now in Edinburgh and three in Dublin; their early provenance is not recorded, but it is highly likely that they came from the same collection. One of the Vaughan Turners in Dublin shows the same subject but from a different vantage point (fig.37).

Turner was evidently especially impressed by the dramatic location of the Châtel Argent – a ruined eleventh-century castle, dominated by a circular tower, which was built over a Roman site. In both watercolours he has also depicted the church of Santa Maria, located below the castle, which he may well have visited to admire its sixteenth-century frescoes.

It has been suggested that these watercolours could be connected with Charles Heath's *Great Rivers of Europe*, a printmaking project launched in 1833, which was planned to build on Turner's studies of the Loire, but eventually abandoned.

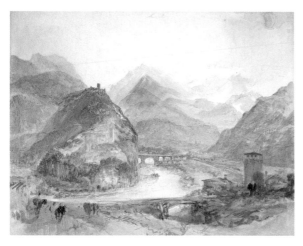

Fig.37 · *Châtel Argent, near Villeneuve, Switzerland*
National Gallery of Ireland, Dublin

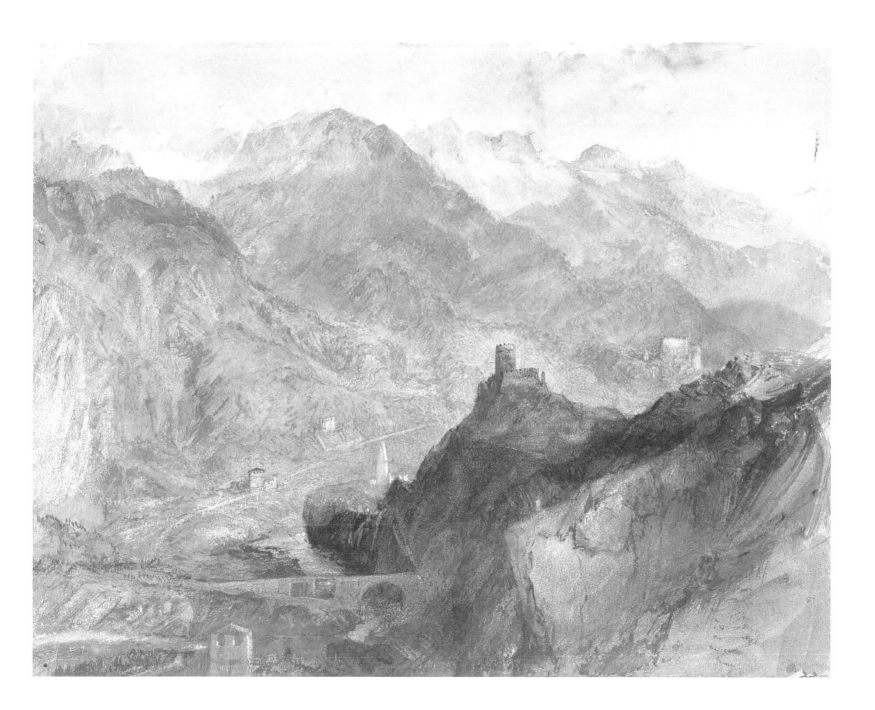

24 *Verrès in the Val d'Aosta*

c.1836–40? · watercolour and pen and red ink, with scraping out on paper · 25.6 × 27.8cm
D NG 865

Turner depicts the River Evançon rushing through
the centre of Verrès, a venerable town which can
trace its history back to Roman times. It is domi-
nated by its castle, at the upper right, which was
constructed in the twelfth century, although its
form as depicted by the artist dates from a building
campaign in the late fourteenth. At the left,
the building above the town is the Collegiata di
St Gilles, an older architectural complex, founded
over a thousand years ago, which became a convent.
Napoleon stayed there at the outset of his second
Italian campaign.

 Verrès in the Val d'Aosta is a slightly problematic
work in terms of dating. It is connected with
Turner's 1836 Swiss tour, as studies by the artist in
his so-called *'Fort Bard'* sketchbook (Tate Britain)
made then can be associated with it. But the way it
has been worked up in watercolour with a nibbed
pen (for example on the rooftops at the left) is
typical of Turner's later work. So it may have
been painted, or at least embellished, some time
after 1836.

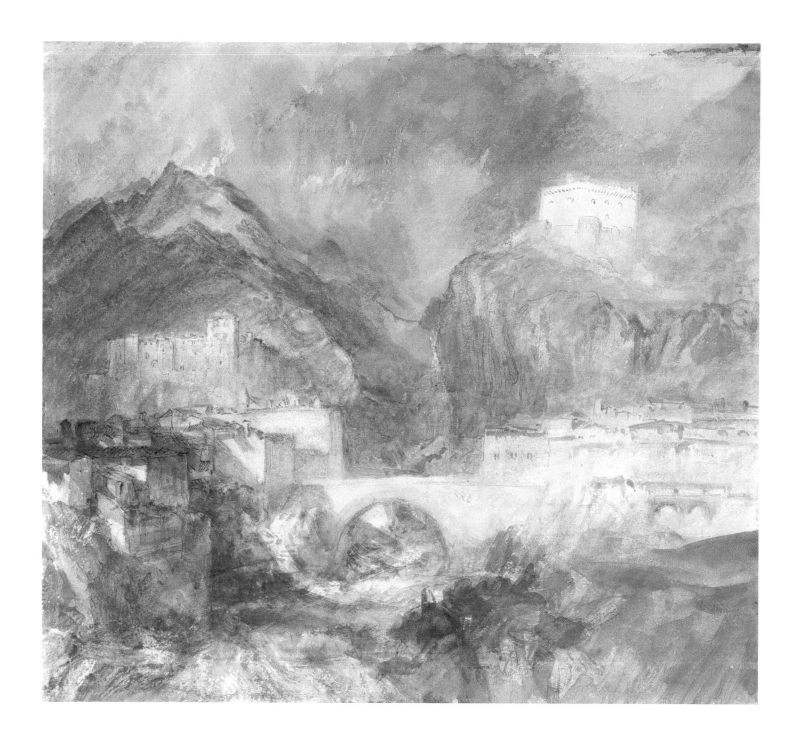

25 *Coblenz and Ehrenbreitstein from the Mosel*

c.1839 · watercolour and gouache on blue paper · 13.8 × 18.9cm
D NG 879

Turner made a number of tours of the three great rivers of northern Europe, the Rhine, Meuse and Mosel, revelling in the drama and variety of scenes they offered, which often featured dramatic cliffs and splendid castles (see plate 8). This beautiful study dates from 1839, when Turner undertook his second tour of the Mosel, and is based on a pencil sketch in his *'Cochem to Coblenz'* sketchbook (Tate Britain). He departed for Europe at the beginning of August 1839, declaring in a letter to the painter Pickersgill 'I am on the Wing for the continent ...' Turner probably crossed the Channel on a steam

yacht and travelled from Ostend to Brussels by train, before completing the rest of his journey by boat, by carriage, and on foot. He was back in London by the end of September and had filled five sketchbooks during his tour.

He shows the Mosel curving in the foreground and flowing beneath an ancient bridge before merging with the Rhine. Ehrenbreitstein, the massive fortress dominating the scene, was originally a medieval castle. It was beseiged by the French (1794–9), and subsequently largely destroyed, before being re-built (1816–34) during the period when the Rhine province belonged to Prussia. So Turner depicts it in its reconstructed form. The artist first studied the fortress in 1817, and subsequently made numerous drawings and watercolours on all his later visits, in some of which he used it as a symbol of German nationalism (fig.38).

One of the finest consequences of his 1839 tour was the great series of gouaches on blue paper from which this study comes. The vibrancy of such works was based on the experience of creating earlier series of gouaches by the artist, including those he made at Petworth House in Sussex in the 1820s, and when studying the rivers of France in the early 1830s. Almost all the other studies in the 1839 series form part of Turner's bequest to the nation, and are now housed in Tate Britain. They were not engraved, and it is unclear how Vaughan's work left the artist's possession.

Fig.38 · *Ode to the Germans: Ehrenbreitstein*
National Gallery of Scotland, Edinburgh

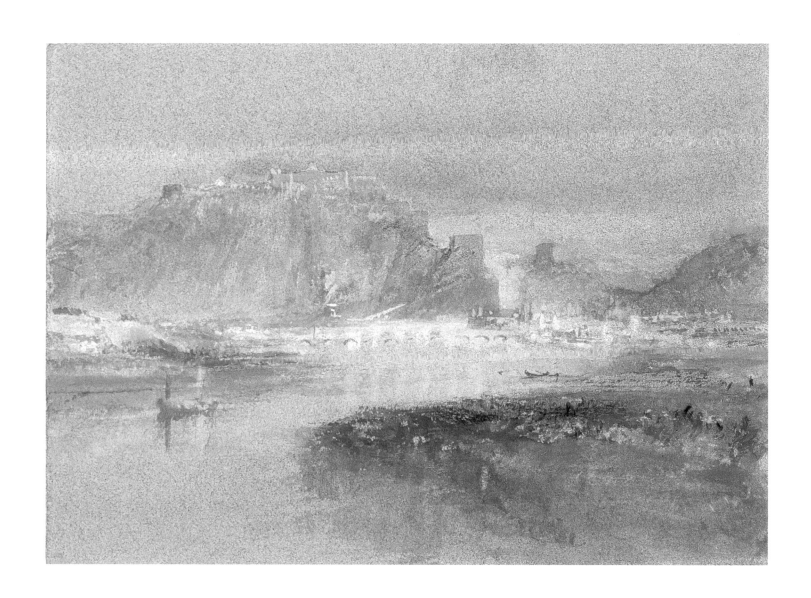

26 The Piazzetta, Venice

1840 · watercolour and gouache and pen and ink, with scraping out on paper · 22.1 × 32.1cm
D NG 871

Turner immersed himself in the study of Venice – its buildings, setting and unique light and atmosphere – during three short visits to the city made in 1819, 1833 and 1840. It can reasonably be argued that it is the 170 watercolours that resulted from these tours, rather than his pencil sketches or oil paintings, which illustrate most effectively the depth of the inspiration it provided. Vaughan owned nine of them; six are now in Edinburgh and three in Dublin. At the time Turner was studying Venice it was part of the Austro-Hungarian Empire and, although no longer a great Mediterranean power, held an irresistible appeal for Romantic writers and artists. Lord Byron, whose work Turner admired, published his famous verses on Venice in 1818 (for him ' … her structures rise/ As from the stroke of an enchanter's wand'), and Turner matched such rhapsodic descriptions with his sparkling watercolours.

This remarkable work dates from his final visit in 1840, undertaken when Turner was aged sixty-five. He arrived in Venice on 20 August, remained until 3 September, and was accompanied by his cousin, Henry Harpur, a solicitor, and Henry's wife, Eleanor. Judging by the watercolours he produced the three travellers must have experienced some dramatic summer storms, as a group of works he created – among which this is the most spectacular – record violent weather.

The Piazzetta, the political and ceremonial heart of Venice, is framed at the left by the Libreria Marciana; the artist looks between the columns surmounted with statues of Saint Theodore and the winged lion of Saint Mark, towards the amber façade of the Doge's Palace. A brilliant crack of lightning bursts across the sky, illuminating part of San Marco, and appears almost contained within the Piazzetta, as figures scatter for cover beneath. The lightning was defined by scratching the surface of the watercolour to reveal the white of the Whatman paper. This was a technique often employed by Turner to create highlights, although rarely with such inspired results. He could have used the blunt end of a brush or a pocket knife, or alternatively his thumbnail, which he is reputed to have grown like an 'eagle-claw' for just such a purpose. The varied textures of the roughened paper are clearly visible (fig.39).

Fig.39

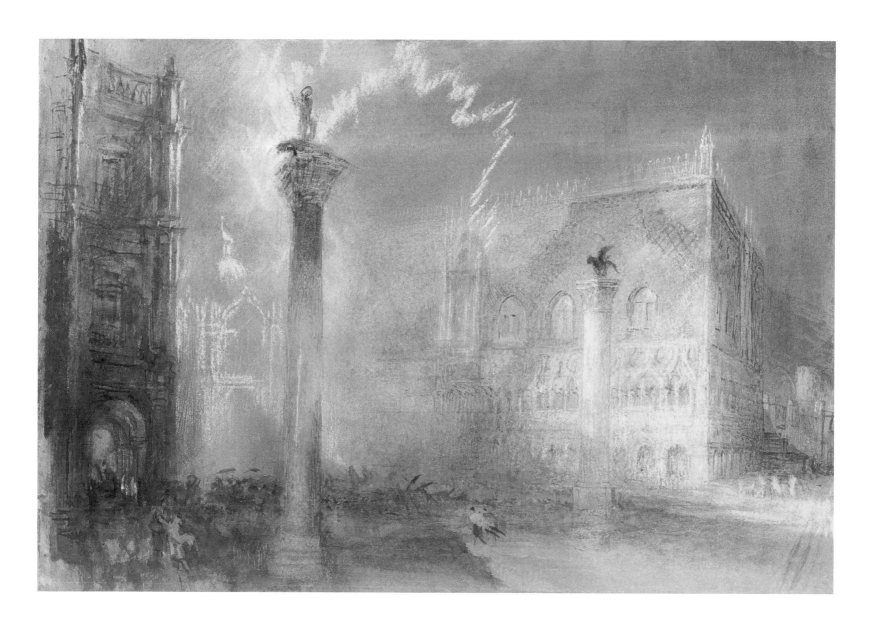

27 *The Grand Canal by the Salute, Venice*

1840 · watercolour on paper · 22.2 × 32.2cm
D NG 888

The great Baroque basilica of Santa Maria della Salute, which was designed by Longhena and is located near the entrance to the Grand Canal features in many of Turner's Venetian studies, with its distinctive dome appearing on the skyline. This is, however, the artist's only work in which he scrutinises its façade close up and defines in some detail the church's complex exterior, richly articulated with pediments, pilasters and volutes. The forms of the architecture are established using a pen dipped in watercolour, but it is not their precise definition that concerns him, as the building appears to dissolve amid shafts of brilliant sunlight that descend from the upper right.

A gondola can be seen in the narrow canal beside the church, in front of the Abbey of San Gregorio. Turner sketched from such boats, and a contemporary account of him working in this way has survived: the artist William Callow (1812–1908) noted in his *Autobiography* (1908):

One evening whilst I was enjoying a cigar in a gondola I saw in another one Turner sketching San Giorgio, brilliantly lit by the setting sun. I felt quite ashamed of myself idling away the time whilst he was hard at work so late.

In 1840 both men were staying at the Hotel Europa in the Palazzo Giustiniani-Morosini, on the Grand Canal, opposite Santa Maria della Salute; shown left and right respectively in Miller's engraving (fig.40). Turner used his hotel room as a temporary studio in which he could work up in watercolour compositions that he would initially have sketched outdoors.

Fig.40 · William Miller (1796–1882) after Turner
The Grand Canal, Venice
National Gallery of Scotland, Edinburgh

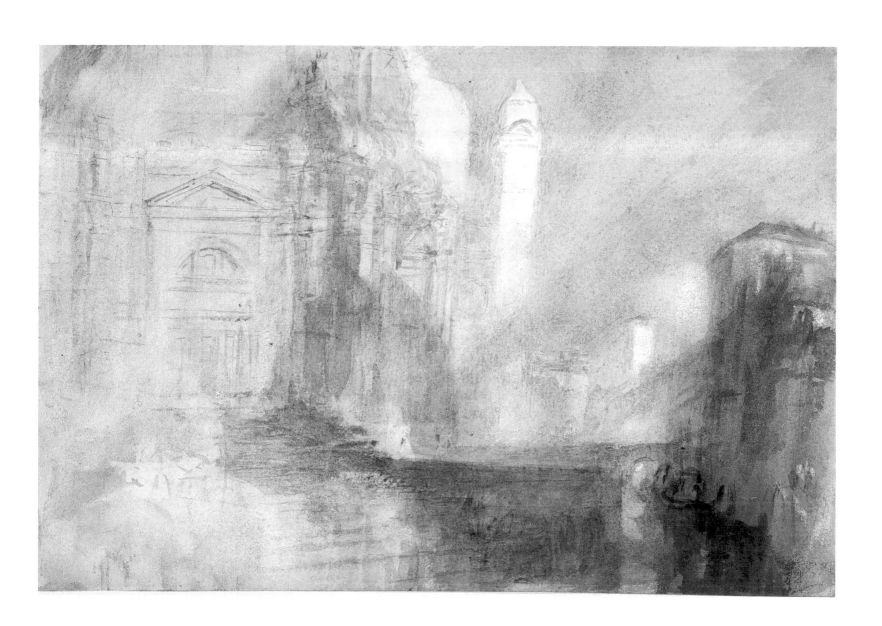

28 *Venice from the Laguna*

1840 · watercolour and gouache and pen and ink, with scraping out on paper · 22.1 × 32cm
D NG 872

This is one of the most dramatic of all Turner's watercolours of Venice. The city is indistinctly silhouetted on the horizon and a violent storm is about to engulf it. Two clusters of wooden piles (*bricole*) which mark channels across the lagoon are broadly painted at the right. It is the only Venetian work in which the artist includes a steamer, which ploughs through the waves (fig.41), while a sailing boat approaches from the left and others remain anchored at the right. To create the effect of the broken trail of steam rising from the boat Turner dabbed the paint, and his fingerprints are just visible on the surface of the watercolour.

A photograph of this work taken in 1862 was given the subtitle *Trieste Steamer,* and the artist departed from the city in 1840 on this boat. He had

used such a form of transport elsewhere in Europe, including the Western Isles of Scotland, and steam-ships appear in a number of his works, perhaps most famously in his oil painting of 1838–9, *The Fighting Temeraire* (The National Gallery, London). In all of these he chronicles rather than condemns the advance of such technology.

Turner's friend, the painter Sir David Wilkie (1785–1841), left Venice by the same route in 1826, and praised 'the quietness, the comfort, and the celerity of this conveyance'. Not all contemporaries were, however, delighted that such a form of transport was part of the Venetian scene. John Ruskin was more judgemental, and in a letter of 1845 to his father bitterly complained of the intrusion of steamboats:

How painful it is to be in Venice now … There is no single spot … where her spirit remains; the modern work has set its plague spot everywhere; the moment you begin to feel, some gaspipe business forces itself on the eye …

Venice from the Laguna was painted on a sheet of paper from Turner's so-called *'Storm'* sketchbook which was used during and after his 1840 visit. It has been suggested that it was left with Turner's dealer and executor, Thomas Griffith (b.1795), who then sold the watercolours after the artist's death. Nineteen sheets from it have been identified and are now widely dispersed, chiefly among British public collections. They include *The Piazzetta, Venice* (plate 26) and *The Grand Canal by the Salute* (plate 27).

Fig.41

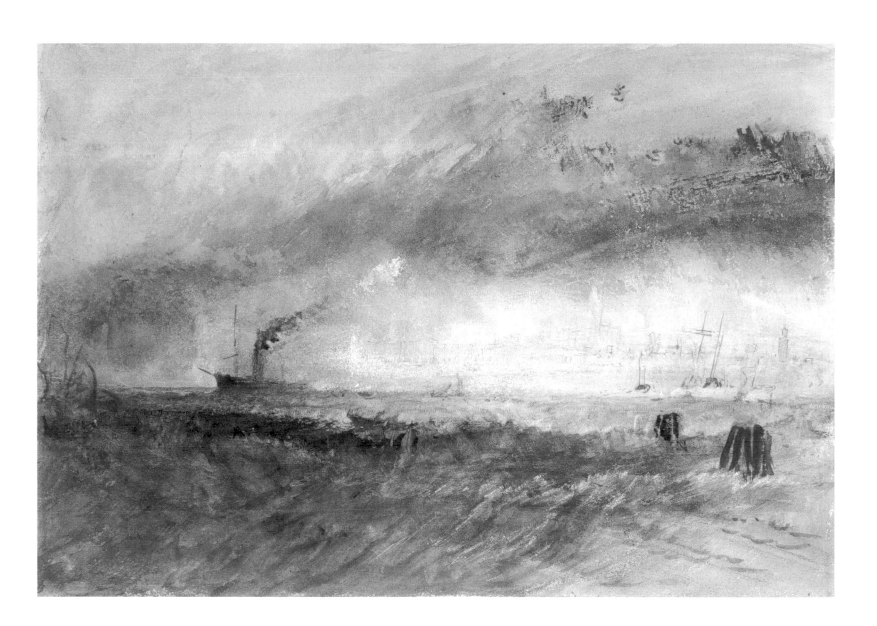

29 *Palazzo Balbi on the Grand Canal, Venice*

1840 · watercolour and gouache over pencil and black chalk on buff paper · 23.1 × 30.7cm
D NG 873

This is a particularly freely executed study of the Grand Canal, dating from Turner's 1840 visit to Venice. The basis of the composition (the outlines of the buildings and the cloud forms) was established by the artist in pencil and then the watercolour added – possibly on the spot, or back in his hotel room. The Rialto Bridge can just be seen in the distance, framed to either side of the glassy canal by the façades of some of Venice's grandest buildings. The Palazzo Balbi, which dominates the scene at the left, was constructed for Nicolò Balbi, following the designs of Alessandro Vittoria, in the 1580s.

The vista chosen is an especially famous one, which was memorably depicted by the great eighteenth-century view-painter Canaletto (1697–1768). Turner was familiar with Canaletto's paintings and prints and created a specific homage to the artist in 1833, an oil painting entitled, *Bridge of Sighs, Ducal Palace and Custom-House, Venice: Canaletti painting* (Tate Britain). In this work, with a great deal of licence, he depicted Canaletto actually working on an oil painting in the open air; he must have known, however, that Canaletto would have made drawings outside and returned to his studio with them to work on canvas, so employing the practice Turner himself adopted.

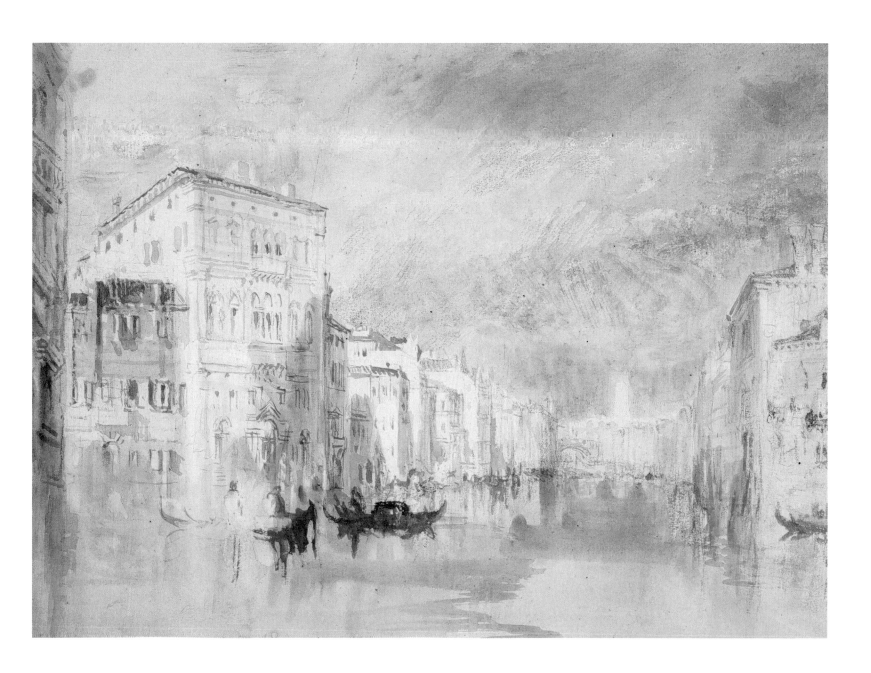

30 *The Rialto, Venice*

1840 · watercolour and pencil over black chalk on buff paper · 22.7 × 30.2cm
D NG 874

The Rialto Bridge, the focus of the commercial district of the city, was designed by Antonio da Ponte and built between 1588 and 1591. It was the only means of crossing the Grand Canal on foot at the time of Turner's visits to Venice. When he first studied it in 1819 he made numerous pencil sketches from various viewpoints; these were used as the basis for some memorable watercolours, including another in Vaughan's collection, which he bequeathed to Dublin, showing the canal thronged with boats, from just below the bridge (fig.42).

The Edinburgh watercolour is worked in a very similar sketchy manner and with a comparable palette to Turner's study of the *Palazzo Balbi* (plate 29). It shows to the left of the bridge an arcaded building, the Fondaco dei Tedeschi, which was originally occupied by the German merchants trading in the city. The church tower beyond it is that of San Bartolomeo. To the right is the sixteenth-century Palazzo dei Camerlenghi, the home of the Venetian exchequer, the lowest floor of which was used as a debtors' prison.

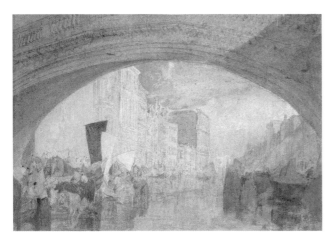

Fig.42 · *The Grand Canal from below the Rialto Bridge, Venice*
National Gallery of Ireland, Dublin

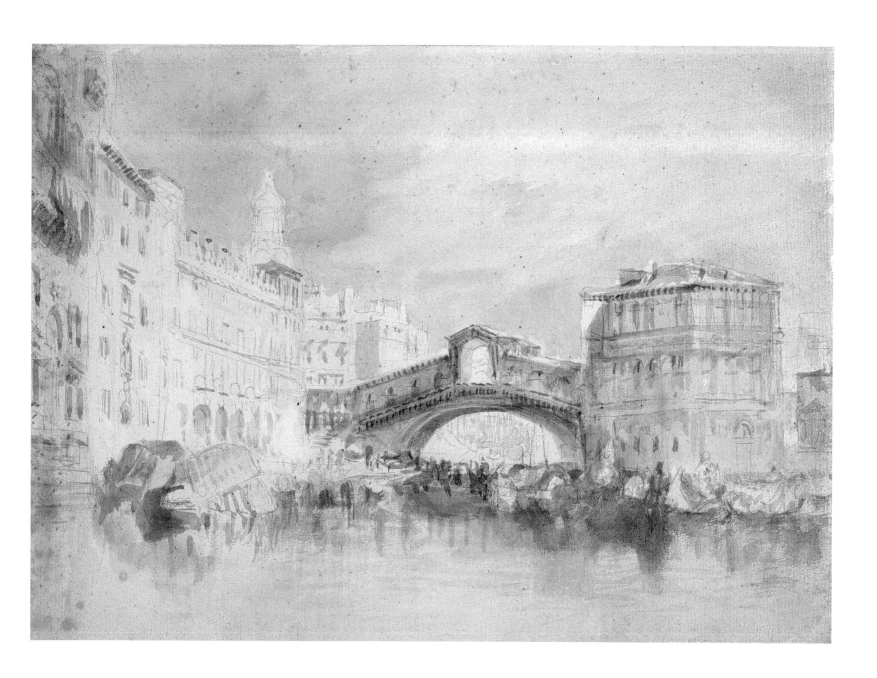

31 *The Sun of Venice*

1840 · watercolour on paper · 21.9 × 32cm
D NG 875

A group of *bragozzi* – the fishing boats of Venice – are depicted in a morning heat haze. The central boat is being rowed as its sails provide little power during such a calm, and it is the craft behind, whose yellow sail is decorated with a sun and crescent moon that provides the work with its title. Beyond, to the left, can be seen the entrance to the Grand Canal, with the silhouette of the church of Santa Maria della Salute suggested in blue wash.

The distinctive emblem on the sail may have been an invention of Turner's, although it might have been suggested to him by the type of decorations to be found on such vessels, of which he had made a number of slight studies in pencil during his Venetian trips. A similar subject reappeared in his oil painting entitled *The Sun of Venice Going to Sea* (fig.43), which was exhibited at the Royal Academy in 1843, three years after his last visit to the city.

The artist appended the following troubling lines from his own poem, *Fallacies of Hope*, to the title of the picture in the academy's catalogue:

> *Fair shines the morn, and soft the zephyrs blow,*
> *Venezia's fisher spreads his painted sails so gay,*
> *Nor heeds the demon in grim repose*
> *Expects his evening prey.*

The note of doom here may not yet have been considered when the watercolour was developed.

John Ruskin clearly had Turner's oil painting – and possibly this study – in mind when he wrote a letter to his father from Venice in 1845 in which he described how:

> *... at six in the morning, with the early sunlight just flushing its folds, out came a fishing boat with its painted sail full to the wind, the most gorgeous orange and red, in everything, form, colour, & feeling, the very counterpart of the Sol di Venezia.*

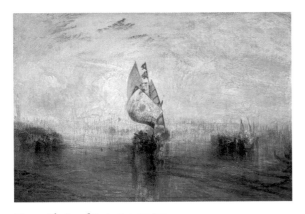

Fig.43 · *The Sun of Venice Going to Sea*
Tate Britain

32 *Falls of the Rhine at Schaffhausen, Front View*

1841 · watercolour and gouache and pen and ink, with scraping out on paper · 23.1 × 28.8cm
D NG 867

Turner first saw the Falls of Schaffhausen in Switzerland – Europe's largest waterfalls – in 1802, and the diarist Farington noted his description of them: 'the Great fall at Schaffhausen is 80 feet, – the width of the fall about four times and a half greater that its depth. The rocks above the fall are inferior to those above the fall of Clyde, but the fall itself is much finer.'

He made watercolours of the falls at the time, and then in 1806 exhibited a painting entitled *Fall of the Rhine at Schaffhausen* at the Royal Academy. It was fiercely criticised by other artists and reviewers, but this did not prevent him returning to the subject, which he depicted again in the early 1830s. This watercolour and the two related works also in the Vaughan Bequest to Edinburgh date, however, from Turner's 1841 Swiss tour, during which he made ten studies. It was typical of Turner to explore a number of different viewpoints of a particular subject – a practice which the Schaffhausen water-colours demonstrate. It has been suggested that the timing of his visit was ideal as the Rhine was heavily swollen because of melted snow and therefore the falls were at their most dramatic. Most of the watercolours in this group are very freely worked by Turner, giving a powerful impression of the colour, scale and noise of such a spectacle.

Vaughan owned a fourth view of the falls, which he bequeathed to the National Gallery in London, and is now in the collection of Tate Britain.

33 Falls of the Rhine at Schaffhausen, Side View

1841 · watercolour and gouache and pen and ink, with scraping out on paper 23 × 10.6cm
D NG 868

Turner adopted a particular technique to evoke the effects of spray and highlights on the water in these waterfall studies, which involved preparing his paper with a grey wash, over which he depicted the subject, before rubbing and scraping the surface. Finally, he brought greater definition to the contours of the landscape by adding delicate lines of red watercolour applied with a pen.

John Ruskin provided a memorable description in his diary of standing by the falls in 1835, which matches some of the effects Turner was seeking to record in his Schaffhausen sequence:

… you feel as if you were being sucked down into the abysses of an Atlantic. The mountains of foam which are relieved whitely against the blue sky appear to be closing over you and the thunder of the cataract drowns every sound of the world, and its voice is heard alone.

Ruskin revisited and depicted the falls himself in the early 1840s – partly as a homage to Turner's work of this period. He showed his own watercolour (now in the Fogg Art Museum, Harvard) to the artist, and was delighted that Turner was suitably impressed.

34 *Falls of the Rhine at Schaffhausen, Moonlight*

1841 · watercolour and gouache and pen and ink, with scraping out on paper · 22.9 × 28.5cm
D NG 869

This, the third in the sequence of Schaffhausen views in the collection of the National Gallery of Scotland, provides an especially interesting contrast with the much earlier and more prosaic depiction of waterfalls, also in Vaughan's collection (see plate 7), in which a similar spectacle is viewed from a comparable vantage point.

Turner painted quite a large number of nocturnes, enjoying the subtleties of depicting moonlight on water; here he has defined ripples in the foreground by removing ribbons of wet wash with a dry brush. He has also replaced the lines of red watercolour used in the daytime views of the falls with green. Unusually, he also inscribed this work at the lower right: *Falls of the Rhein / 1841*. This note is of some importance as it confirms the dating of the whole sequence of studies from which it comes.

Charles Stokes, the first owner of Vaughan's view of the falls, was a friend of Turner and an enthusiast for his work. Stokes's money came from stockbroking and his interests ranged from geology and lithography, to collecting watercolours and old master prints. He owned a large number of Turner's watercolours and created the first catalogue of his *Liber Studiorum*.

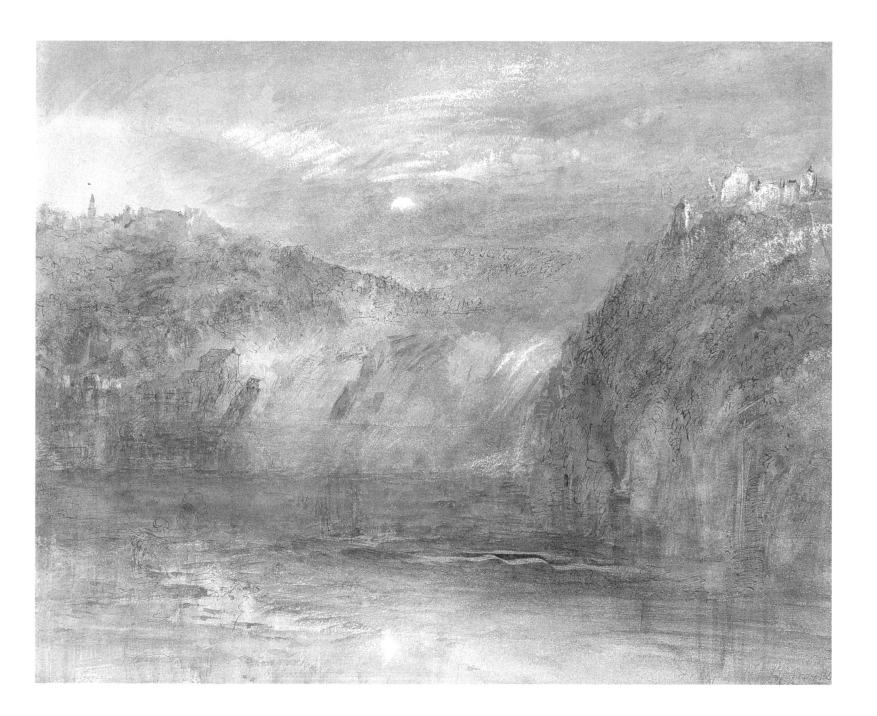

35 Schwyz

1843 · watercolour over black chalk with pen and brown ink on paper 22.6 × 28.8cm
D NG 863

In 1843 Turner made his most extensive studies of
Brunnen and Schwyz by Lake Lucerne. In this
ambitious watercolour, which dates from the
summer of that year, he has depicted a view of the
twin peaks of the Mythen, as seen from the banks of
the River Muota, with the town of Schwyz beyond.
The artist shows a number of onlookers on the
banks of the river, with cattle, apparently half-
submerged, struggling to cross it; at the left he has
also rapidly sketched in a horse-drawn cart (fig.44),
of the type he may have used to discover the area.

The Vaughan watercolour can be related to
several pencil studies in Turner's '*Lake of Zug and
Goldau*' sketchbook (Tate Britain).

Fig.44

36 *The St Gothard Pass at the Devil's Bridge*

1843? · watercolour and gouache and pencil, with scraping out on paper · 23.2 × 28.9cm
D NG 877

The St Gothard Pass provides one of the main strategic routes over the Alps into Italy. Turner first explored the pass in 1802, making drawings of its splendid surroundings, which inspired later watercolours, oil paintings and prints. He reached the so-called Devil's Bridge, where a narrow road crosses over a foaming torrent; a battle had been fought on the spot in 1801 between the French and Austrians. He did not return until the early 1840s, and this, one of his last depictions of the pass, probably dates from 1843. He suggests a small group of figures at the lower left, looking beneath an arc of ominous snow and rain-filled clouds to a window of sunlight beyond. Such an effect recalls his oil painting of 1812, *Snow Storm: Hannibal and his Army Crossing the Alps* (fig.45) in which an apocalyptic storm is unforgettably depicted.

Although now recognised as among the greatest of Turner's achievements, dramatic late watercolours by the artist such as his alpine views of the 1840s, were not widely appreciated during his life. They were chiefly acquired by loyal, long-standing friends and patrons – men such as Ruskin, Windus and Munro of Novar, rather than new collectors.

Fig.45 · *Snow Storm: Hannibal and his Army Crossing the Alps*
Tate Britain

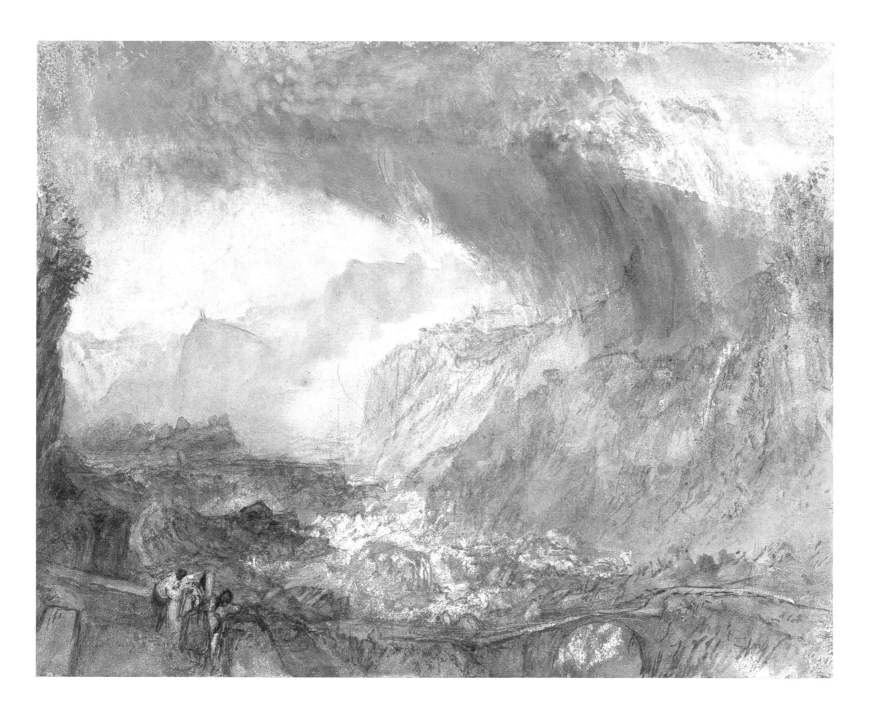

37 *Thun*

1844? · watercolour and pencil, with scraping out on paper · 24.9 × 36.4cm
D 0.8 866

This study can be connected with Turner's final trip to Switzerland in 1844, when he made a circular tour, visiting Basel, Schaffhaussen, Zurich, Goldau, Lucerne, Interlaken, and finally Thun and Berne. Thun is set on either side of the River Aare by the lake after which it is named; it provides a fine vantage point from which to view the Eiger and the Jungfrau.

Thun is renowned for its castle and charming medieval centre. The low-lying old town is notable because of the arcading of the main streets and its cobbled squares. Steps lead up from it to the turreted castle which was completed in 1190, and now contains an historical museum.

The town and lake of Thun were studied by Turner on a number of earlier occasions; for example, sketches he made during his first Swiss tour of 1802 formed the basis of two plates in his *Liber Studiorum* print series.

It is likely that Henry Vaughan visited Thun on his own European tours, because as well as owning Turner's watercolour, he commissioned an oil painting of Lake Thun from the Swiss artist Alexandre Calame in 1852, which is now in the collection of the National Gallery, London.

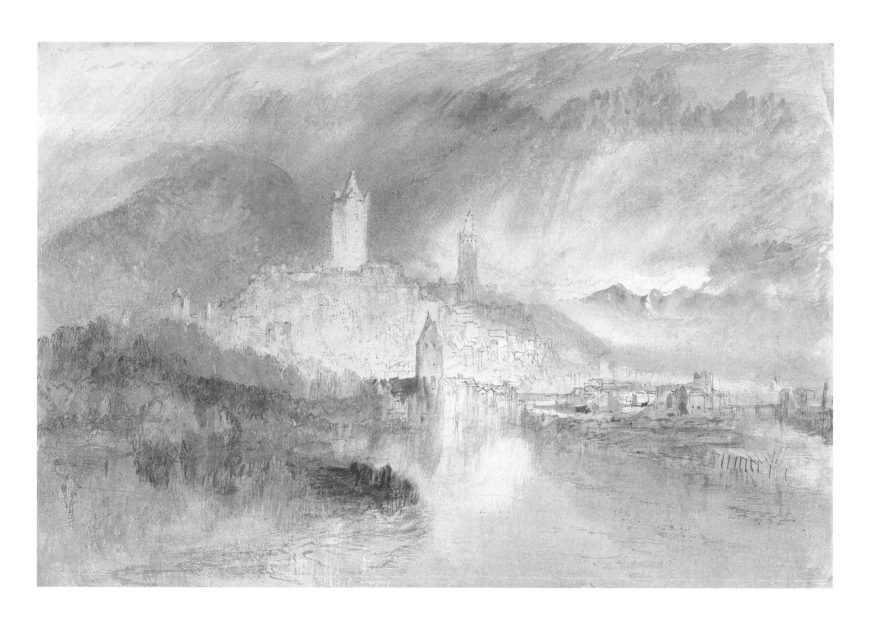

38 *Heidelberg*

c.1846 · watercolour and gouache, with scraping out on paper · 37.4 × 55.3cm
D NG 885

Heidelberg presented a splendid spectacle for nineteenth-century painters, as an ancient university town with a fine castle on the River Neckar, a picturesque tributary of the Rhine. Turner visited on three occasions: in 1833, 1840 and 1844. He was clearly initially entranced by what he saw, as on his first brief visit he made over fifty pencil sketches of various aspects of its architecture and setting. It was only in the 1840s however that he started to work up watercolours and oil paintings which were based on these studies. This watercolour, which probably dates from about 1846, is one of the finest of all the artist's late works. Here he has moved far beyond a concern for topographical accuracy and created a glowing, almost hallucinatory image. The figures in the foreground dissolve into their surroundings, and the depiction of the light from the setting sun, as it

glances across and gilds the high, thin clouds, is especially masterly. The watercolour is also distinguished by its size; it is one of the largest of the Vaughan Turners in Edinburgh and was probably always meant to be an exhibition piece.

Turner was aware of the historical resonances which Heidelberg had from a British perspective. It was briefly the home of Elizabeth, the daughter of King James VI and I, who in 1613 married Friedrich V, the Elector Palatine, and later reigned as the so-called 'Winter Queen' of Bohemia. The artist worked on an oil painting in 1844–5, now in Tate Britain, which shows their court at Heidelberg. But this slightly later watercolour and related works, which include a similar composition in a private collection, that was made to be engraved (fig.46), do not explicitly explore such themes; they celebrate instead in a more generalised, operatic sense the drama and beauty of the scene. Turner was perhaps evoking in such images the views of his friend the portrait painter Sir Thomas Lawrence, who stated in a letter published in 1831: 'Of all the grandly romantic spots, by nature, art and interesting circumstances. Heydelberg [sic] is the first.'

Fig.46 · Thomas Abiel Prior (1809–1886) after Turner
Heidelberg from the Opposite Bank of the Neckar
National Gallery of Scotland, Edinburgh

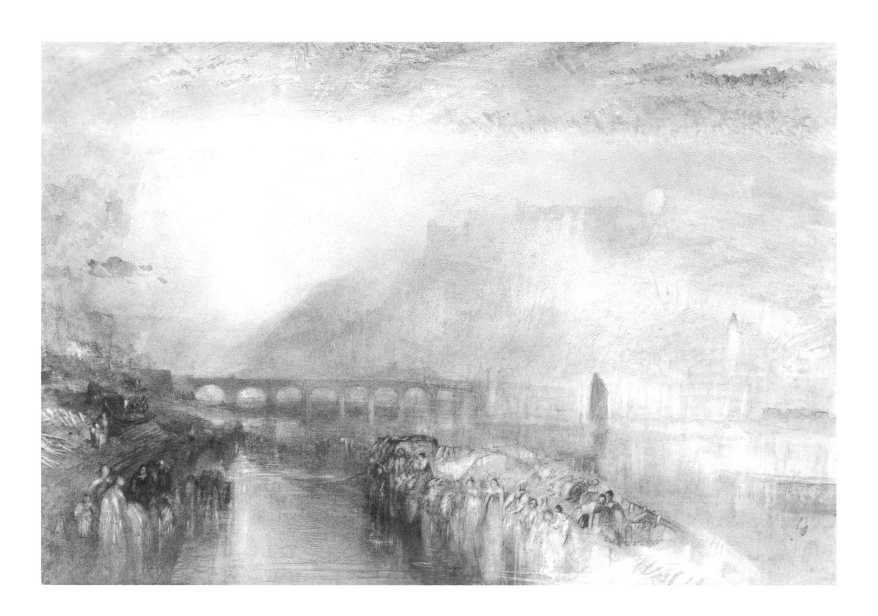

Fig.47 · After Alfred, Count D'Orsay (1801–1852)
Portrait of Joseph Mallord William Turner (1775–1851)
National Gallery of Scotland, Edinburgh

Joseph Mallord William Turner: A Chronology

1775
23 April, Joseph Mallord William Turner born, Covent Garden, London, son of a barber, William Turner, and Mary Turner (née Marshall).

1787
Makes first signed and dated watercolours.

1789
Earliest known sketchbook. Informal studies with the artist Thomas Malton. 11 December, admitted to the Royal Academy Schools.

1790
Exhibits first work (a watercolour) at the Royal Academy.

1791
First West Country tour: Bristol, Bath, Malmesbury. Part-time scene painter at the Pantheon Opera House.

1792
July – August, first tour of South and Central Wales.

1793
Awarded the 'Greater Silver Pallet' for landscape drawing by the Society of Arts. Earliest experiments with oil painting.

1794
Watercolours at the Royal Academy attract critical notice. First commission for an engraving. Summer, first Midlands tour to make drawings for engraving: visits Lincoln, Ely and Peterborough, returning via North Wales. Begins copying works by J.R. Cozens and others at Dr Monro's 'Academy' with Thomas Girtin (until 1797).
Plates 1–5 produced during this period.

1795
June – July, South Wales tour. August – September, Isle of Wight tour. Receives commissions for engravings.

1796
First oil painting exhibited at Royal Academy (*Fishermen at Sea off the Needles*, Tate Britain).

1797
Summer, first North of England tour, including the Lake District.

1798
Literary texts are appended to titles of his paintings in the Royal Academy exhibition for the first time. Summer, visits Malmesbury, Bristol and North Wales.

1799
August – September, works with William Beckford at Fonthill, Wiltshire. September – October, tour of Lancashire and North Wales. Elected Associate Royal Academician. November/December, moves to 64 Harley Street, London.

1800
Turner attaches his own verses to the title of a painting for the first time.

1801
June – August, first tour of Scotland, returning via the Lake District.
Plates 6 and 7 produced during this period.

1802
12 February, elected Royal Academician at the age of twenty-six. Mid-July – mid-October, first European tour through France, Savoy and Switzerland: makes sketches and notes in the Louvre, Paris (especially of works by Titian, Poussin and Claude).

1804
Turner opens his own gallery in his house in Harley Street, London. Death of his mother.

1805
Summer, oil sketching on a boat on the River Thames.

1806
Starts the *Liber Studiorum* print series. Exhibits paintings at the inaugural exhibition of the British Institution.

1807
Appointed Professor of Perspective at the Royal Academy.

1808
Summer, tour of Cheshire and Wales. First visits Walter Fawkes at Farnley Hall, Yorkshire; returns regularly until 1824.

1809
Summer, visits Petworth, Sussex. Autumn, visits Yorkshire and Cumberland.

1810
Moves to Queen Anne Street, London.

1811
First lectures on perspective delivered at the Royal Academy. Commissioned to create watercolours for *Picturesque Views on the Southern Coast of England* (completed 1826). Tours Dorset, Devon, Cornwall and Somerset. Starts his poem, the *Fallacies of Hope*.

1812
Exhibits *Snow Storm: Hannibal and his Army Crossing the Alps* (Tate Britain, London).

1813
Tours Devon and visits Yorkshire.

1814
Another tour of Devon. Turner's work receives critical attention from William Hazlitt.

1815
Visits Yorkshire. Turner meets Canova who describes him as a 'grand génie'.

1816
Tour of Yorkshire and Lancashire. Becomes a Visitor to the Painting School at the Royal Academy.

1817
Tour of Belgium (including Waterloo), the Rhine between Cologne and Mainz, and Holland, returning via Yorkshire. Plate 8 produced during this period.

1818
Commissioned to make watercolours for Hakewill's *A Picturesque Tour in Italy* (published 1818–20). Commissioned by Sir Walter Scott to make watercolours for *Provincial Antiquities and Picturesque Scenery of Scotland*. October – November, visits Edinburgh and the Scottish Lowlands.

1819
Paintings first exhibited at Sir John Leicester's Gallery, London. Watercolours first exhibited at Walter Fawkes's London house in Grosvenor Place. Turner enlarges his London house in Queen Anne Street with a new gallery. August – February 1820, tour of Italy, visiting Turin, Como, Venice, Rome, Naples, returning via Florence and Turin.

1821
Exhibits watercolours at the Cooke Gallery, Soho Square, London. Visits Paris and Northern France. Copies works by Claude in the Louvre.

1822
August, sails up the east coast to Edinburgh for King George IV's state visit. Commissioned to create watercolours for *The Rivers of England* and *Marine Views* series.

1823
Tour along the south-east coast of England. Visits Yorkshire.

1824
Tours south-east England, East Anglia, Liège, Verdun, Luxemburg, Trier, Coblenz, Calais and Dieppe. Begins work on *Picturesque Views in England and Wales*.

1825
Tour of Holland, the Rhine and Belgium.

1826
Tour of Brittany and the Loire. Commissioned by Samuel Rogers to provide illustrations for his poem *Italy*.

1827
Visits the Isle of Wight (late July – September) and Petworth, Sussex. Plates 9–11 produced during this period.

1828
January – February, delivers last lectures at the Royal Academy as Professor of Perspective. Second tour of Italy, visiting Paris, Lyons, Avignon, Florence, Rome, returning via Loreto, Ancona, Bologna, Turin and Lyons.
Plate 12 produced during this period.

1829
Exhibits at the Egyptian Hall, Piccadilly, London. Visits Paris and Normandy. Death of Turner's father; the artist draws up first draft of his will.

1830
Exhibits a watercolour for the last time at the Royal Academy. Tour of the Midlands.

1831
Commissioned by Robert Cadell to illustrate Sir Walter Scott's, *Poetical Works* and *Prose Works*; visits Scotland, stays at Abbotsford.
Plates 13–16 produced during this period.

1832
Exhibits at Messrs Moon, Boys and Graves, Pall Mall, London for the first time. Visits the Channel Islands, Paris and its environs.
Plate 17 produced during this period.

1833
Tours Belgium, Germany and Austria, via Vienna, and visits Venice. Buys works at the Monro sale.

1834
Illustrations to Byron's poems exhibited at Colnaghi's, London. Exhibits at the Society of British Artists. Travels along the Rhine.

1835
Summer tour of Europe, including visits to Copenhagen, Berlin, Dresden, Prague, Nuremberg, the Rhine and Rotterdam.
Plates 18 and 19 produced during this period.

1836
Publication of George Francis White's, *Views in India, chiefly among the Himalaya Mountains*. Tour of France, Switzerland and Val d'Aosta with Munro of Novar. October, Ruskin's first letter to Turner.
Plates 20–4 produced during this period.

1837
Publication of the *Poetical Works of Thomas Campbell*. Resigns as Royal Academy Professor of Perspective.

1839
Summer, tour of the Mosel and the Meuse.
Plate 25 produced during this period.

1840
22 June, first recorded meeting with John Ruskin, at the home of Turner's agent, Thomas Griffith. Tour of Southern Germany, Austria and Venice.
Plates 26–31 produced during this period.

1841
Tour of Switzerland, visiting Luzerne, Constance and Zurich.
Plates 32–4 produced during this period.

1842
Late summer, tour of Switzerland and the Rhineland.

1843
Watercolours of Swiss views sold by Griffith to Munro of Novar and John Ruskin. Publication of the first volume of John Ruskin's *Modern Painters*.
Plates 35 and 36 produced during this period.

1844
Tour of Switzerland, Heidelberg and the Rhine.
Plate 37 produced during this period.

1845
Elected Acting President of the Royal Academy. Tour of northern France. Autumn, visits Dieppe and the coast of Picardy; Turner's last European tour.

1846
Probably moves to Chelsea.
Plate 38 produced during this period.

1850
Exhibits for the last time at the Royal Academy.

1851
19 December, dies at 119 Cheyne Walk, Chelsea. 30 December, buried in St Paul's Cathedral.

Notes on the Plates

1
Lake Albano, 1794–7

D NG 882

Blue and grey washes over pencil on paper, 42.2 × 54.7cm

Inscribed, on the *verso*: *Lake Albano or Nemi, Castel Gandolfo 31a*

PROVENANCE: Henry Vaughan Bequest 1900

EXHIBITED: Annual January Turner exhibition from 1900, National Gallery of Scotland

REFERENCES: Armstrong 1902, p.238; Campbell 1993, no.5, p.74

The related drawing in Leeds City Art Gallery is cat. 846/28. Campbell 1993 noted that a similar Monro School drawing of Lake Nemi, attributed to Turner, was exhibited at the Royal Academy Turner exhibition (1975, cat. B23). For the Monro School see Jefferiss 1976 and Wilton 1984.

2
Rye, Sussex, 1794–7

D NG 853

Blue and grey washes over pencil, with some scraping out on paper, 19.6 × 26.9cm

PROVENANCE: Henry Vaughan Bequest 1900

EXHIBITED: Annual January Turner exhibition from 1900, National Gallery of Scotland

REFERENCES: Armstrong 1902, p.275; Campbell 1993, no.2, p.73

3
The Medway, 1794–7

D NG 854

Blue and grey washes over pencil, with some scraping out on paper, 20.6 × 29.7cm

PROVENANCE: Henry Vaughan Bequest 1900

EXHIBITED: Annual January Turner exhibition from 1900, National Gallery of Scotland

REFERENCES: Armstrong 1902, p.266; Campbell 1993, no.3, p.73

4
Beachy Head, Looking Towards Newhaven, 1794–7

D NG 855

Blue and grey washes over pencil, with some scraping out on paper, 20.3 × 27.5cm

PROVENANCE: Henry Vaughan Bequest 1900

EXHIBITED: RA 1887, no.12; Annual January Turner exhibition from 1900, National Gallery of Scotland

REFERENCES: Armstrong 1902, p.241; Campbell 1993, no.4, p.74

< Detail from plate 11

5

Old Dover Harbour, 1794–7

D NG 856

Blue and grey washes over pencil on paper,
27.2 × 20.9cm

PROVENANCE: Henry Vaughan Bequest 1900

EXHIBITED: RA 1887, no.10; Annual January
Turner exhibition from 1900, National Gallery of
Scotland

REFERENCES: Armstrong 1902, p.249; Campbell
1993, no.6, p.74

6

Durham, 1801

D NG 889

Watercolour over pencil on paper, 40.9 × 25cm

WATERMARK: *J. Whatman / 1794*

PROVENANCE: Henry Vaughan Bequest 1900

EXHIBITED: Annual January Turner exhibition
from 1900, National Gallery of Scotland

REFERENCES: Armstrong 1902, p.251; Finberg
1909, vol. I, p.124; Wilton 1979, no.316; Dawson
1988, p.62; Campbell 1993, no. 8, p.74

D NG 889 and D NG 886 are associated with works
from Turner's *'Smaller Fonthill'* sketchbook
(XLVIII, Tate), which Turner used on his tour to
Scotland and the North of England in 1801.
Campbell 1993 further notes that two closely
related watercolours can also be found in the
'Helmsley' sketchbook (LIII ff.97–8, Tate). Other
Durham views from the 1801 visit include a study
of the castle viewed from the same position in
Leeds City Art Gallery (cat.5.225/52), and a study
of the city looking towards the cathedral, as seen
from a little further upstream beside the River
Wear (Wilton 1979, no.314, private collection).

7

The Falls of Clyde, 1801

D NG 886

Watercolour over pencil, with some scraping out
on two sheets of paper joined and laid down,
41.3 × 52.1cm

WATERMARK: *J. Whatman / 1794*

PROVENANCE: Henry Vaughan Bequest 1900

EXHIBITED: Annual January Turner exhibition
from 1900, National Gallery of Scotland

REFERENCES: Armstrong 1902, p.247; Finberg
1909, vol. I, p.124; Wilton 1979, no.322; Dawson
1988, p.62; Campbell 1993, no. 9, p.75

The watermark can be compared with those from
the *'Smaller Fonthill'* sketchbook (XLVIII, Tate).

8

*Neuwied and Weissenthurm, on the
Rhine, Looking Towards Andernach,*
1817–19

D NG 857

Watercolour and pen and ink and gum, with
scraping out on paper, 18.6 × 28.8cm

PROVENANCE: William Bernard Cooke: James
Slegg; Henry Vaughan Bequest 1900

EXHIBITED: Cooke Gallery 1823, no.34; RA 1892,
no.66; Annual January Turner exhibition from
1900, National Gallery of Scotland

REFERENCES: Armstrong 1902, p.268; Finberg
1961, pp.256, 278, 484, no.282; Wilton 1979,
no.689; Powell 1991, pp.36, 100; Campbell 1993,
no.10, p.75

D NG 857 was engraved in 1853 by R. Brandard (see
Rawlinson 1908–13, no.670).

Campbell 1993 noted that Turner filled four
sketchbooks with pencil drawings during his 1817
Rhine tour (Tate CLIX–CLXX). D NG 857 is closely
based on a drawing in the *'Waterloo and Rhine'*
sketchbook (Tate CLX, f.78v.–79r.).

9

Man of War, 1827

D NG 852

Pencil on paper, 16.1 × 22.6cm

Inscribed, lower right, by the artist, with his
initials: *JMWT*

PROVENANCE: Henry Vaughan Bequest 1900

EXHIBITED: Annual January Turner exhibition
from 1900, National Gallery of Scotland

REFERENCES: Dawson 1988, p.76; Warrell 1991,
nos.76–7; Campbell 1993, no.7, p.77

10

Harbour View, mid-1820s?

D NG 880

Watercolour and gouache on blue paper,
13.9 × 18.9cm

PROVENANCE: Henry Vaughan Bequest 1900

EXHIBITED: Annual January Turner exhibition
from 1900, National Gallery of Scotland

REFERENCES: Armstrong 1902, p.256; Wilton
1979, no.921; Campbell 1993, no.32, p.82

11

Sea View, mid-1820s?

D NG 881

Watercolour and gouache on blue paper, 13.5 × 19cm

PROVENANCE: Henry Vaughan Bequest 1900

EXHIBITED: Annual January Turner exhibition from 1900, National Gallery of Scotland

REFERENCES: Armstrong 1902, p.277; Wilton 1979, no.922; Campbell 1993, no.33, p.82

The quotation comes from Ruskin 1843–1860, vol. V, part IX, chapter XI, pp.5–6.

12

Lake Como Looking Towards Lecco, c.1828

D NG 878

Watercolour and gouache and black chalk on blue paper, 14.2 × 18.8cm

PROVENANCE: Henry Vaughan Bequest 1900

EXHIBITED: Annual January Turner exhibition from 1900, National Gallery of Scotland

REFERENCES: Armstrong 1902, p.247; Wilton 1979, no.1038; Campbell 1993, no.34, p.82

The quotation comes from Wilton 1989, pp.226–7; it is also used in Hamilton 1997, p.294.

Campbell 1993 suggests that D NG 878 dates from the late 1820s; Wilton 1979 proposes c.1828. Although one of Turner's sketchbooks dating from 1819 contains studies of the Lake Como area (CLXXIV, Tate), none of the drawings in it relate directly to this work.

13

Rhymer's Glen, Abbotsford, 1831–2

D NG 858

Watercolour and pen and ink over pencil, with scraping out on paper, 14 × 9cm

PROVENANCE: Benjamin Godfrey Windus, by 1840; Henry Vaughan Bequest 1900

EXHIBITED: RA 1892, no.65; Annual January Turner exhibition from 1900, National Gallery of Scotland

REFERENCES: Armstrong 1902, p.273; Finley 1972, pp.359–85, p.366, no.51; Wilton 1979, no.1119; Finley 1980, pp.117–8, 208–9; Gage 1980, p.300; Campbell 1993, no.12, p.76; Piggott 1993, no.103, p.56, p.99

The sketchbook referred to is the 'Edinburgh' sketchbook (f.52, Tate, CCLXVIII).

For the nature of the relationship between Turner and Scott see especially Thomson 1999.

14

Chiefswood Cottage, Abbotsford, 1831 2

D NG 859

Watercolour and pen and ink over pencil on paper, 15 × 10cm

PROVENANCE: Benjamin Godfrey Windus, by 1840; Henry Vaughan Bequest 1900

EXHIBITED: RA 1892, no.55; Annual January Turner exhibition from 1900, National Gallery of Scotland

REFERENCES: Armstrong 1902, p.246; Wilton 1979, no.1118; Finley 1980, pp.209–10; Gage 1980, p.300; Campbell 1993, no.13, p.76; Piggott 1993, no.102, p.56, p.99

15

Melrose, 1831–2

D NG 860

Watercolour, with scraping out on paper, 10 × 15.6cm

PROVENANCE: Henry Vaughan Bequest 1900

EXHIBITED: Annual January Turner exhibition from 1900, National Gallery of Scotland

REFERENCES: Armstrong 1902, p.266; Finberg 1961, p.492, no.375; Wilton 1979, no.1080; Finley 1972, pp.359–85, p.366, note 51, p.369; Finley 1980, pp.162–3; Campbell 1993, no.14, p.77

D NG 860 is based on a pencil drawing (ff.14v-15) in the 'Abbotsford' sketchbook (CCLXVII, Tate Britain, London), which was used by Turner on his visit to the Borders in 1831. For the engravings after D NG 860 see Rawlinson 1908-13, no.503.

16

Loch Coruisk, Skye, 1831–4

D NG 861

Watercolour, with scraping out on paper, 8.9 × 14.3cm

PROVENANCE: Henry Vaughan Bequest 1900

EXHIBITED: Annual January Turner exhibition from 1900, National Gallery of Scotland

REFERENCES: Armstrong 1902, p.248; Wilton 1979, no.1088; Finley 1980, pp.137–8; Gage 1987, pp.220–1; Campbell, 1993, no.15, p.77

For the engravings after D NG 861 see Rawlinson 1908-13, no.511. For the connection with Macculloch see Gage 1987.

17

Llanberis Lake and Snowdon, Caernarvon, Wales, c.1832

D NG 884

Watercolour and gouache an pen and ink on paper, 31.8 × 47.1cm

PROVENANCE: Charles Heath, 1833; G.B.Windus; purchased by Henry Vaughan, 1854; Henry Vaughan Bequest 1900

EXHIBITED: Moon, Boys and Graves 1833, no.76; Manchester 1857; Annual January Turner exhibition from 1900, National Gallery of Scotland

REFERENCES: Armstrong 1902, p.262; Finberg 1961, p.496; Shanes 1979, p.43, no.64; Wilton 1979, no.855; Wilton 1980, p.181, cat.110; Herrmann 1990, p.133; Campbell 1993, no.16, p.77

Campbell 1993 notes that several drawings connected with Llanberis are in the *'Dolbadarn'* sketchbook of 1799 (XLVI, ff.21, 44, 98v., Tate). D NG 884 was engraved by J.T. Willmore in 1832 and published in 1834 as no.3 in part VIII of *Picturesque Views* (Rawlinson 1908–13, no. 279).

18

Durham, c.1835

D NG 883

Watercolour and gouache and gum, with scraping out on paper, 29.5 × 44cm

PROVENANCE: Henry Vaughan Bequest 1900

EXHIBITED: Manchester 1857; RA 1887, no.70; Annual January Turner exhibition from 1900, National Gallery of Scotland

REFERENCES: Armstrong 1902, p.251; Shanes 1979, p.47; Wilton 1979, no.873; Herrmann 1990, p.136; Campbell 1993, no.17, p.78

Some of the earliest preparatory drawings for this view can be found in the *'Helmsley sketchbook'* of 1801 (LIII, ff.16, 20, 22, Tate). For the engravings after D NG 861 see Rawlinson 1908–13, no. 297.

19

Falls Near the Source of the Jumna in the Himalayas, c.1835

D NG 862

Watercolour, with scraping out on paper, 13.6 × 20.2cm

PROVENANCE: Henry Vaughan Bequest 1900
EXHIBITED: RA 1892, no.50; Annual January Turner exhibition from 1900, National Gallery of Scotland

REFERENCES: Armstrong 1902, p.259; Wilton 1979, no.1295; Herrmann 1990, pp. 213–14; Campbell 1993, no.11, p.76

20

Sion, Capital of the Canton Valais, c.1836

D NG 864

Watercolour and gouache on paper, 24.1 × 30cm

PROVENANCE: Henry Vaughan Bequest 1900
EXHIBITED: RA 1892, no.50; Annual January Turner exhibition from 1900, National Gallery of Scotland

REFERENCES: Armstrong 1902, p.277; Wilton 1979, no.1447; Campbell 1993, no.18, p.78

Campbell 1993 notes that dating Turner's views of Sion is problematic because none of his sketchbook studies can be positively identified with it. He points out that the only sketchbook related by Ruskin to a visit to Sion (CCCXXXVII, Tate) was dismissed as spurious by Finberg (1909 vol. II, p.1061).

21

Sion, Rhône, c.1836

D NG 876

Watercolour, with scraping out on paper, 24.5 × 27.7cm

PROVENANCE: Henry Vaughan Bequest 1900

EXHIBITED: Annual January Turner exhibition from 1900, National Gallery of Scotland

REFERENCES: Armstrong 1902, p.279; Wilton 1979, no.1446; Campbell 1993, no.19, p.78

Campbell 1993 notes that D NG 876 was formerly identified as a view of Splügen, but the work is most likely to depict a view of Sion from the south-east. See Finberg 1961 pp.360–1.

22

Monte Rosa (?), 1836?

D NG 887

Watercolour on paper, 24.3 × 33.9cm

PROVENANCE: Henry Vaughan Bequest 1900

EXHIBITED: Annual January Turner exhibition from 1900, National Gallery of Scotland

REFERENCES: Armstrong 1902, p.274; Cormack 1975, p.62, no.35; Wilton 1979, no.1433; Campbell 1993, no. 20, p.78

None of the studies in Turner's sketchbooks relates exactly to the composition of D NG 887.

This work has traditionally been called: *Monte Rosa (or the Mythen, near Schwyz)*, but Turner did not visit Schwyz on his 1836 tour. The same mountain range appears in earlier drawings in the *'Lake Thun'* sketchbook of 1802 (LXXXVI, ff.43, 44, Tate). A watercolour in the collection of the Fitzwilliam Museum, Cambridge which dates from the mid-1830s (reg.1612) may also be related.

23

Châtel Argent, in the Val d'Aosta, near Villeneuve, 1836

D NG 870

Watercolour and gouache, with scraping out on paper, 24 × 30.2cm

PROVENANCE: Henry Vaughan Bequest 1900

EXHIBITED: Annual January Turner exhibition from 1900, National Gallery of Scotland

REFERENCES: Armstrong 1902, p.239; Boase, 1956, pp.283–93, p.289; Finberg 1961, p.361; Cormack 1975, p.62; Wilton 1979, no.1434; Dawson 1988, p.100; Campbell 1993, no.22, p.79

On entering the National Gallery's collection D NG 870 was called *Among the Italian Alps*. Turner sketches in his *'Fort Bard' sketchbook'* of 1836 (CCXCIV, Tate) were made in the vicinity of Chatel Argent; f.83 and f.85 are closest to D NG 870.

24

Verrès in the Val d'Aosta, c.1836–40?

D NG 865

Watercolour and pen and red ink, with scraping out on paper, 25.6 × 27.8cm

PROVENANCE: Henry Vaughan Bequest 1900

EXHIBITED: Annual January Turner exhibition from 1900, National Gallery of Scotland

REFERENCES: Armstrong 1902, p.240; Wilton 1979, no.1435; Campbell 1993, no.21, p.79

As Campbell (1993) noted several rather slight sketches of Verrès appear in the *'Fort Bard'* sketchbook (CCXCIV, Tate), which was used by Turner on his 1836 tour of Switzerland and two of these studies (ff.50–1) relate closely to D NG 865.

25

Coblenz and Ehrenbreitstein from the Mosel, c.1839

D NG 879

Watercolour and gouache on blue paper, 13.8 × 18.9cm

PROVENANCE: Henry Vaughan Bequest 1900

EXHIBITED: Annual January Turner exhibition from 1900, National Gallery of Scotland

REFERENCES: Armstrong 1902, p.252; Wilton 1979, no.1034; Powell 1991, p.149; Campbell 1993, no.35, p.83

Campbell 1993 notes that D NG 879 is closely related to a pencil drawing in the *'Cochem to Coblenz'* sketchbook (CCXCI, 43 v Tate).

26

The Piazzetta, Venice, 1840

D NG 871

Watercolour and gouache and pen and ink, with scraping out on paper, 22.1 × 32.1cm

WATERMARK: *J. WHATMAN / 1834*

PROVENANCE: Henry Vaughan Bequest 1900

EXHIBITED: Annual January Turner exhibition from 1900, National Gallery of Scotland

REFERENCES: Armstrong 1902, p.282; Finberg 1961, p.355; Wilton 1979, no.1352; Stainton 1985, no.88, p.65; Campbell 1993, no.26, p.80; Warrell 2003, pp.118–23, p.258

27

The Grand Canal by the Salute, Venice, 1840

D NG 888

Watercolour on paper, 22.2 × 32.2cm

PROVENANCE: Henry Vaughan Bequest 1900

EXHIBITED: RA 1892, no.66; Annual January Turner exhibition from 1900, National Gallery of Scotland

REFERENCES: Armstrong 1902, p.282; Wilton 1979, no.1370; Stainton 1985, no.92, p.66; Campbell 1993, no.30, p.81; Warrell 2003, pp.168–71, p.258

28

Venice from the Laguna, 1840

D NG 872

Watercolour and gouache and pen and ink, with scraping out on paper, 22.1 × 32cm

WATERMARK: *J. WHATMAN / 1834*

PROVENANCE: Henry Vaughan Bequest 1900

EXHIBITED: Annual January Turner exhibition from 1900, National Gallery of Scotland

REFERENCES: Armstrong 1902, p.282; Wilton 1979, no.1371; Stainton 1985, no.89, p.65; Campbell 1993, no.27, p.81; Warrell 2003, pp.233–5, p.258, p.265, note 6

D NG 872 was photographed in 1862 by J. Hogarth, see Warrell 2003, p.265, note 6.

29

*Palazzo Balbi on the Grand Canal,
Venice*, 1840

D NG 873

Watercolour and gouache over pencil and black
chalk on buff paper, 23.1 × 30.7cm

PROVENANCE: Henry Vaughan Bequest 1900

EXHIBITED: RA 1892, no.53; Annual January
Turner exhibition from 1900, National Gallery of
Scotland

REFERENCES: Armstrong 1902, p.282; Wilton
1979, no.1372; Campbell 1993, no.28, p.81;
Warrell 2003, fig.90, p.97

Campbell 1993 notes that another although wider
version of this view, is in a roll sketchbook dating
to around 1840 (CCCXV Tate).

30

The Rialto, Venice, 1840

D NG 874

Watercolour and pencil over black chalk on buff
paper, 22.7 × 30.2cm

PROVENANCE: Henry Vaughan Bequest 1900

EXHIBITED: *Old Masters*, Royal Academy of Arts,
London, 1892, no.54; Annual January Turner
exhibition from 1900, National Gallery of
Scotland

REFERENCES: Armstrong 1902, p.282; Wilton
1979, no.1369; Stainton 1985, Campbell 1993,
no.29, p.81; Warrell 2003, fig.157, p.152.

Campbell 1993 notes a very similar view of the
Rialto, seen from the other side of the bridge,
appears on f.2 in a roll sketchbook (CCCXV, Tate),
(see also D NG 873).

31

The Sun of Venice, 1840

D NG 875

Watercolour on paper, 21.9 × 32cm

PROVENANCE: Henry Vaughan Bequest 1900

EXHIBITED: Annual January Turner exhibition
from 1900, National Gallery of Scotland

REFERENCES: Armstrong 1902, p.282; Wilton
1979, no.1374; Stainton 1985, no.95, p.67;
Campbell 1993, no.31, p.82; Warrell 2003,
pp.225–7, p.258

The Ruskin quotation is used in Stainton 1985.

32

*Falls of the Rhine at Schaffhausen,
Front View*, 1841

D NG 867

Watercolour and gouache and pen and ink, with
scraping out on paper, 23.1 × 28.8cm

PROVENANCE: Possibly purchased from Turner
by Charles Stokes; by inheritance to Hannah
Cooper, 1853; Henry Vaughan Bequest 1900

EXHIBITED: Annual January Turner exhibition
from 1900, National Gallery of Scotland

REFERENCES: Armstrong 1902, p.276;
Herrmann 1970, p.696; Wilton 1979, no.1464;
Campbell 1993, no.36, p.83

D NG 867 along with D NG 868 and D NG 869 may
be sheets from the *'Fribourg, Lausanne and Geneva'*
sketchbook (CCCXXXII, Tate), which was used by
Turner in 1841.

33

*Falls of the Rhine at Schaffhausen,
Side View*, 1841

D NG 868

Watercolour and gouache and pen and ink, with
scraping out on paper, 23 × 28.6cm

PROVENANCE: Possibly purchased from Turner
by Charles Stokes; by inheritance to Hannah
Cooper, 1853; Henry Vaughan Bequest 1900

EXHIBITED: Annual January Turner exhibition
from 1900, National Gallery of Scotland

REFERENCES: Armstrong 1902, p.276;
Herrmann 1970, p.696; Wilton 1979, no.1463;
Campbell 1993, no.37, p.83

For the Ruskin quotation see Hewison, Warrell
and Wildman 2000, p.65.

34

*Falls of the Rhine at Schaffhausen,
Moonlight*, 1841

D NG 869

Watercolour and gouache and pen and ink, with
scraping out on paper, 22.9 × 28.5cm

Inscribed, lower right corner: *Falls of the Rhein/
1841*

PROVENANCE: Possibly purchased from Turner
by Charles Stokes; by inheritance to Hannah
Cooper, 1853; Henry Vaughan Bequest 1900

EXHIBITED: Annual January Turner exhibition
from 1900, National Gallery of Scotland

REFERENCES: Armstrong 1902, p.276;
Herrmann 1970, p.696; Wilton 1979, no.1460;
Campbell 1993, no.38, p.84

35

Schwyz, 1843

D NG 863

Watercolour over black chalk and pen and brown ink on paper, 22.6 × 28.8cm

WATERMARK: *J. WHATMAN / TURKEY MILL 18[11?]*

PROVENANCE: Henry Vaughan Bequest 1900

EXHIBITED: Annual January Turner exhibition from 1900, National Gallery of Scotland

REFERENCES: Armstrong 1902, p.276; Wilton 1979, no.1487; Campbell 1993, no.24, p.80; Warrell 1995, p.71

The *'Lake of Zug and Goldau'* sketchbook (CCCXXXI, Tate) features several pencil sketches that can be related to D NG 863 (ff.12v., 23, 23v).

36

The St Gothard Pass at the Devil's Bridge, 1843?

D NG 877

Watercolour and gouache and pencil, with scraping out on paper, 23.2 × 28.9cm

WATERMARK: *J. WHATMAN / TURKEY MILL*

PROVENANCE: Henry Vaughan Bequest 1900

EXHIBITED: Annual January Turner exhibition from 1900, National Gallery of Scotland

REFERENCES: Armstrong 1902, p.255; Wilton 1979, no.1497; Campbell 1993, no.23, p.79

Campbell 1993 pointed out that many studies of the Pass featuring the Devil's Bridge appear in the *'St. Gothard and Mont Blanc'* and *'Lake Thun'* sketchbooks (LXXV and LXXVI, eg. f.73, Tate). These sketchbooks were used in 1802. The style and dimensions of D NG 877 are consistent with several other views of the St Gothard Pass, which were produced by Turner during the early 1840s (e.g. Fitzwilliam Museum, Cambridge, reg. 586–7).

37

Thun, 1844?

D NG 866

Watercolour and pencil, with scraping out on paper, 24.9 × 36.4cm

PROVENANCE: Henry Vaughan Bequest 1900

EXHIBITED: Annual January Turner exhibition from 1900, National Gallery of Scotland

REFERENCES: Armstrong 1902, p.280; Wilton 1979, no.1504; Campbell 1993, no.25, p.80

Campbell 1993 notes that D NG 866 bears a number of similarities to coloured drawings in the *'Thun and Interlaken'* sketchbook (CCCXLVI Tate), which was used by Turner on his 1844 trip to Switzerland.

38

*Heidelberg, c.*1846

D NG 885

Watercolour and gouache, with scraping out on paper, 37.4 × 55.3cm

PROVENANCE: Henry Vaughan Bequest 1900

EXHIBITED: Annual January Turner exhibition from 1900, National Gallery of Scotland

REFERENCES: Armstrong 1902, p.257; Wilton 1979, no.1554, pp.244–5; Campbell 1993, no.39, p.84

Several large views of Heidelberg can be connected with preliminary studies the artist made on tours during the early 1840s (for example, CCCLXV f.34, which is dated 10 March 1841, Tate). Another watercolour, similar in composition is in the Manchester City Art Gallery (reg.1917.106). A third watercolour of the same view, but with different detailing, was engraved by T.A. Prior in 1846 (see Rawlinson 1908–13, no.663), and is in a private collection. The engraving is illustrated here.

The Lawrence quotation is from *The Life of Thomas Lawrence* by D.E. Williams, 1831; it is quoted in Nugent and Croal 1996, p.108.

Bibliography

AGNEW'S 1913
Thomas Agnew and Sons, *Exhibition of Watercolour Drawings by J.M.W. Turner, RA*, 1913

AGNEW'S 1967
Thomas Agnew and Sons, *Loan Exhibition of Paintings and Watercolours by J.M.W. Turner, RA*, 1967

ARMSTRONG 1902
Sir W. Armstrong, *Turner RA*, London, 1902

BELL 1901
C.F. Bell, *The Exhibited Works of J.M.W. Turner*, London, 1901

BOWER 1990
P. Bower, *Turner's Papers*, London, 1990

BOASE 1956
T.S.R. Boase, 'English Artists in the Val d'Aosta', *Journal of the Warburg and Courtauld Institutes*, XIX, 1956, pp.283–93

BROWN 1992
D.B. Brown, *Turner and Byron*, Tate, London, 1992

BULL 1986
D. Bull, 'Henry Vaughan's Bequest', *The Antique Collector*, January, 1986, pp.62–7

BUTLIN & JOLL 1977
M. Butlin and E. Joll, *The Paintings of J.M.W. Turner*, New Haven and London, 1977

CAMPBELL 1993
M. Campbell, *A Complete Catalogue of Works by Turner in the National Gallery of Scotland*, National Gallery of Scotland, Edinburgh, 1993

CLIFFORD 1982
T. Clifford, *Turner at Manchester; Catalogue Raisonnée, Collections of the City Art Gallery, Manchester*, Manchester, 1982

COOKE & WEDDERBURN 1903–12
E.T. Cooke and A. Wedderburn, *The Works of John Ruskin*, 1903–12

COOKE GALLERY, 1823
W.B. Cooke Gallery, *Drawings by English Artists*, London, 1823

CORMACK 1975
M. Cormack, *J.M.W. Turner, RA, 1775–1851. A Catalogue of Drawings and Watercolours in The Fitzwilliam Museum, Cambridge*, Cambridge, 1975

DAWSON 1988
B. Dawson, *Turner in the National Gallery of Ireland*, Dublin, 1988

DICK 1980
J. Dick, *The Vaughan Bequest of Turner Watercolours*, National Gallery of Scotland, Edinburgh, 1980

DNB 2004
The Dictionary of National Biography, Oxford, 2004

EGERTON 1998
J. Egerton, *National Gallery Catalogues. The British School*, London, 1998

FARINGTON
K. Garlick and A. Macintyre (eds.), *The Farington Diary 1793–1821*, New Haven and London, 1978 *et seq.*

FINBERG 1909
A.J. Finberg, *The National Gallery. A Complete Inventory of the Drawings of The Turner Bequest: with which are included The Twenty-Three Drawings Bequeathed by Mr. Henry Vaughan. Arranged Chronologically*, 2 vols., London, 1909

FINBERG 1961
A.J. Finberg, *The Life of J.M.W. Turner RA*, Oxford, 1939, 2nd edn, rev. H.F. Finberg, 1961

FINLEY 1972
G. Finley, 'J.M.W. Turner and Sir Walter Scott: Iconography of a Tour' in *Journal of the Warburg and Courtauld Institutes*, XXXV, 1972, pp.359–85.

FINLEY 1980
G. Finley, *Landscape of Memory; Turner as Illustrator to Scott*, London 1980

FLEMING-WILLIAMS AND PARRIS 1984
I. Fleming-Williams and L. Parris, *The Discovery of Constable*, London, 1984

FORRESTER 1996
G. Forrester, *Turner's 'Drawing Book', The Liber Studiorum*, Tate, London, 1996

FRANCO-BRITISH EXHIBITION 1908
Fine Art Palace, Shepherd's Bush London, *Franco-British Exhibition, British Section, Pictures by Deceased Artists*, 1908

GAGE 1980
J. Gage, *Collected Correspondence of J.M.W. Turner*, Oxford, 1980

GAGE 1987
J. Gage, *J.M.W. Turner 'A Wonderful Range of Mind'*, New Haven and London, 1987

GOODALL 1902
F. Goodall, *Reminiscences of Frederick Goodall*, RA, London and Newcastle, 1902

GUILDHALL 1899
Guildhall Art Gallery, London, *Loan Collection of Pictures and Drawings by J.M.W. Turner*, RA, 1899

HAMBURG 1976
Kunsthalle, Hamburg, *William Turner und die Landschaft seiner Zeit (Kunst um 1800)*, 1976

HAMILTON 1997
J. Hamilton, *Turner, A Life*, London, 1997

HASKELL 2000
F. Haskell, *The Ephemeral Museum, Old Master Paintings and The Rise of the Art Exhibition*, New Haven and London, 2000

HARTLEY 1984
C. Hartley, *Turner Watercolours in the Whitworth Art Gallery*, Manchester, 1984

HERRMANN 1968
L. Herrmann, *Ruskin and Turner*, London, 1968

HERRMANN 1970
L. Herrmann, 'Ruskin and Turner: A Riddle Resolved', *Burlington Magazine*, CXII, 1970, p.696

HERRMANN 1990
L. Herrmann, *Turner Prints: The Engraved Work of J.M.W. Turner*, Oxford, 1990

HEWISON, WARRELL AND WILDMAN 2000
R. Hewison, I. Warrell and S. Wildman, *Ruskin, Turner and the Pre-Raphaelites*, Tate, London, 2000

IRWIN AND WILTON 1982
F. Irwin and A. Wilton, *Turner in Scotland*, Aberdeen, 1982

JEFFERISS 1976
F. Jefferiss (ed.), *Dr Thomas Monro (1759–1833) and the Monro Academy*, ex. cat., Victoria & Albert Museum, London, 1976

JOLL, BUTLIN AND HERRMANN 2001
E. Joll, M. Butlin and L. Herrmann (eds.), *The Oxford Companion to J.M.W. Turner*, Oxford, 2001

LINDSAY 1966
J. Lindsay, *J.M.W. Turner, His Life and Work*, London, 1966

LUGT 1921
F. Lugt, *Les Marques de Collections de Dessins et d'Estampes…*, Amsterdam, 1921

LYLES 1989
A. Lyles, *Young Turner; Early Work to 1800*, London, 1989

LYLES 1992
A. Lyles, *Turner; The Fifth Decade*, London, 1992

LYLES AND PERKINS 1989
A. Lyles and D. Perkins, *Colour into Line: Turner and the Art of Engraving*, London, 1989

MANCHESTER 1857
Manchester City Art Gallery, *Art Treasures of the United Kingdom Collected at Manchester in 1857*

MOON, BOYS AND GRAVES 1833
Moon, Boys and Graves, London, *A Private Exhibition of Drawings by J.M.W. Turner RA*, 1833

MUNICH 1978
Bayerische Staatsgemäldesammlungen, *Munich, Turner und die Dichtkunst*, 1976

NUGENT AND CROAL 1996
C. Nugent and M. Croal, *Turner Watercolours from Manchester*, Memphis, Indianapolis, Omaha and Manchester, 1996

PARIS 1983
Grand Palais, Paris, *J.M.W. Turner*, 1983–4

PIGGOTT 1993
J. Piggott, *Turner's Vignettes*, ex. cat., Tate, London, 1993

POPE-HENNESSY 1964
J. Pope-Hennessy, *Catalogue of Italian Sculpture in the Victoria & Albert Museum*, London, 1964

POSTLE 2005
M. Postle (ed.), *Joshua Reynolds: The Creation of Celebrity*, Palazzo dei Diamanti, Ferrara, Tate Britain, London, 2005

POUNCEY AND GERE 1962
P. Pouncey and J.A. Gere, *Italian Drawings in the Department of Prints and Drawings in the British Museum: Raphael and his Circle*, 2 vols., London, 1962

POWELL 1987
C. Powell, *Turner in the South: Rome, Naples, Florence*, New Haven and London, 1987

POWELL 1991
C. Powell, *Turner's Rivers of Europe: The Rhine, Meuse and Mosel*, London, 1991

RA 1886
Royal Academy, London, *Old Masters*, 1886

RA 1887
Royal Academy, London, *Old Masters*, 1887

RA 1892
Royal Academy, London, *Old Masters*, 1892

RA 1834
Royal Academy, London, *Exhibition of British Art
c.1000–1860*, 1934

RA 1974–5
Royal Academy, London, *Turner, 1775–1851*, 1974–5

RAWLINSON 1908–13
W.G. Rawlinson, *The Engraved Work of J.M.W.
Turner, RA*, London, 1908–13

REYNOLDS 1984
G. Reynolds, *The Later Paintings and Drawings of
John Constable*, New Haven and London, 1984

REYNOLDS 1996
G. Reynolds, *The Early Paintings and Drawings of
John Constable*, New Haven and London, 1996

RUSKIN 1843–1860
J. Ruskin, *Modern Painters*, (1843–1860)

RUSSELL AND WILTON 1976
J. Russell and A. Wilton, *Turner in Switzerland*,
Zurich, 1976

SHANES 1979
E. Shanes, *Turner's Picturesque Views in England and
Wales 1825–1838*, London, 1979

SLOAN 1998
K. Sloan, *J.M.W. Turner, Watercolours from the R.W.
Lloyd Bequest*, The British Museum, London, 1998

STAINTON 1985
L. Stainton, *Turner's Venice*, London, 1985

TATE GALLERY 1931
Tate Gallery, London, *Turner's Early Oil Paintings
(1796–1815)*, 1931

THOMPSON 1972
Colin Thompson, *Pictures for Scotland*, National
Gallery of Scotland, Edinburgh 1972

THOMSON 1999
K. Thomson, *Turner and Sir Walter Scott, The
Provincial Antiquities and Picturesesque Scenery of
Scotland*, ex. cat., National Gallery of Scotland,
Edinburgh, 1999

THORNBURY 1862
W. Thornbury, *The Life of J.M.W. Turner, RA*, 1862
revised edition, London, 1877

UPSTONE 1989
Turner: The Second Decade, Tate, London, 1989

WARRELL 1991
I. Warrell, *Turner: The Fourth Decade*, Tate,
London, 1991

WARRELL 1995
I. Warrell, *Through Switzterland with Turner,
Ruskin's First Selection from the Turner Bequest*, Tate,
London, 1995

WARRELL 2003
I. Warrell *et al.*, *Turner and Venice*, Tate Britain,
London, Kimbell Art Museum, Fort Worth, 2003

WATERFIELD 1998
G. Waterfield (ed.), *Art Treasures of England. The
Regional Collections*, Royal Academy of Arts,
London, 1998

WILDE 1953
J. Wilde, *Italian Drawings in the Department of Prints
and Drawings in the British Museum, Michelangelo
and his Studio*, London, 1953

WILTON 1975
A. Wilton, *Turner in the British Museum, Drawings
and Watercolours*, London, 1975

WILTON 1979
A. Wilton, *J. M. W. Turner His Life and Art*, New
York, 1979

WILTON 1980
A. Wilton, *Turner and the Sublime*, London, 1980

WILTON 1982
A. Wilton, *Turner Abroad: France, Italy, Germany,
Switzerland*, London, 1982

WILTON 1984
A.Wilton, 'The Monro School Question: Some
Answers', *Turner Studies*, IV/2, 1984, pp.8–23

WILTON 1989
A. Wilton, *Turner in his Time*, London, 1989

Notes

1. The sources on Vaughan are disparate: a typed copy of his will is in the archive of the National Gallery of Scotland; posthumous notices were published in *The Times* (27 November 1899; 3 January 1900; 8 May 1901) and *The Athenaeum* (2 December 1899). In addition, see the unpublished typewritten catalogue of works presented by Vaughan to the Slade School, University College, London, 1906; Lugt 1921, nos.1380 and 1381, p.246; Thompson 1972, p.89; Dick 1980; Bull 1986; Dawson 1988; Campbell 1993; Joll, Butlin and Herrmann 2001, p.358 (entry by Luke Herrmann); DNB 2004, vol. 56, p.176 (entry by Luke Herrmann). The letter quoted from here is in the archive of the National Gallery, London: NG 7/84/1886: 2 March 1886 from Henry Vaughan to Sir Frederick Burton: 'My dear Sir/ I beg to offer to the Trustees of the National Gallery the picture called the 'Hay Wain' by John Constable RA – which is now on loan at Burlington House – and would ask you – in case the picture should be accepted – to forward the enclosed letter to the Secretary of the Royal Academy – / I venture to make the suggestion that the picture may not be lined or varnished for one year from the present time – / With thanks for the trouble I would thus give you – I am – my dear Sir – very faithfully yours […]'; letter of 12 March 1886 from Henry Vaughan to Sir Frederick Burton: ' Dear Sir Frederick, / I am happy to be informed by Mr Eastlake that the Trustees do me the favour to accept the picture by Constable./ I should be very much obliged to you to allow that any inscription that may be put upon the picture should be limited to the title of the picture and the name of the artist – and that my name may not appear upon my picture during my life time. / I am – dear Sir Frederick/ Very truly yours/ Henry Vaughan.'

2. Vaughan bequeathed a portrait of his mother by Pickersgill to University College London.

3. The alms houses stood at the corner of Great Suffolk Street and Union Street. They were built by Vaughan in his capacity as a trustee of a charity founded by his sister. They remained in use until 1907 and were eventually demolished after 1971.

4. See Dawson 1988, p.39.

5. Pope-Hennessy 1964: vol. I, Style of Verrocchio, *Head of A Girl*, marble, 47 × 34cm (no.923–1900), pp.168–9, plate no.164. Pope-Hennessy considered Vaughan's sculpture 'a work of great distinction', and suggested that 'The possibility that it is an early work by Verrocchio, executed about 1460–5, under the inspiration of Desiderio, must be seriously entertained.'

6. Edward Dillon; letter of 25 April 1901, see Thompson 1972, p.89.

7. Vaughan's collection can be at least partially reconstructed using his will, and documents in the Victoria & Albert Museum Archives: MA/1/V127. These include a letter to Richard Redgrave RA about the presentation of eighteen photographs for the use of students; a letter from R.A. Thompson (Assistant Director of the South Kensington Museum) saying that Vaughan had decided to lend two Constables (the studies for *The Leaping Horse* and *The Hay Wain*) to the Edinburgh International Exhibition (as well as a letter from Vaughan himself outlining this); an inventory drawn up by Sotheby's of the contents of 28 Cumberland Terrace; and finally, a memorandum of 1900, which outlines all the works that were bequeathed by Vaughan to the Victoria & Albert Museum.

8. NG 1842: Tuscan, fifteenth century, *Heads of Angels*, fresco, irregular shape, 28 × 38cm. An undated letter stuck to the reverse suggests that it was acquired in Florence at the 'Convento delle Poverine, Via della Scala'; however, the Convent referred to is at a different location. The other old master paintings from Vaughan's collection now in the collection of the National Gallery, London, are: NG 1812, Attributed to Lo Spagna (active 1504–died 1528), *Christ at Gethsemane*, perhaps about 1500–5, oil on wood, 34 × 26cm, and NG 1810, Flemish, *Portrait of a Boy Holding a Rose*, about 1660, oil on canvas, 93.4 × 64.8cm. Two later oil paintings were also bequeathed by Vaughan to the National Gallery: NG 1811, Thomas Gainsborough, *The Painter's Daughters Chasing a Butterfly*, c.1756, oil on canvas, 113.7 × 104.8cm and NG 1786, Alexandre Calame, *The Lake of Thun*, 1854, oil on canvas, 59.1 × 78.1cm.

9. Michelangelo Buonarroti (1475–1564), *Seated Nude Man*, pen and brush with brown and grey ink, heightened with white, on paper, 42.1 × 28.7cm, The British Museum, 1887-5-2-116; Sir Peter Paul Rubens (1577–1640), *Hercules Standing on Discord, Crowned by two Genii*, red and black chalk on paper, 47.5 × 32cm, The British Museum, 1900-8-24-138; Rembrandt van Rijn (1606–1669), *The Holy Family in the Carpenter's Workshop*, pen and brown ink with brown wash, touched with white, on paper, 18.4 × 24.6cm, The British Museum, 1900-8-24 144; Claude Lorrain (1604/5–1682), *A Storm at Sea*, red chalk with

pen and brown wash heightened with white on paper, 12.9 × 17.9cm, The British Museum, 1900-8-24-555. The work by Antoine Watteau (1684-1721), which is not reproduced here is also in The British Museum, 1900-8-24-159. For the works by Raphael and his followers acquired by Vaughan see Pouncey and Gere 1962, nos.25, 33, 41, 64 and 228.

10. Wilde 1953. In total Vaughan presented seven works by Michelangelo and his circle to The British Museum: nos. 4, 6, 10, 29, 53, 91, 102.

11. Wilde 1953, p.viii.

12. The Burlington Fine Arts Club survived until 1951. In the nineteenth century the fee for joining was £5 5s and the annual subscription the same amount. For a recent discussion of its significance see Haskell 2000, pp.93-7.

13. He also used the club's exhibitions as something of a showcase for his acquisitions of British art; for example, he lent twenty-six works to the 1871 exhibition, including works by Constable, Reynolds, Gainsborough, Cozens, De Wint, Girtin, Roberts, Rowlandson, Stothard and Turner.

14. For the fullest discussion of this work see Egerton 1998, pp.92-7 (Henry Vaughan owned it by 1871 and bequeathed it to the National Gallery in 1900). Vaughan also bought a drawing by Gainsborough of a *Woman with Three Children* (The British Museum 1901-1-4-1).

15. Reynolds 1996: 09.8; 10.33; 11.30; 11.44; 14.47; 14.45; Reynolds, 1984: 21.1-2; 24.20; 25.2;27.9; 28.4, 27; 29.36; 31.5.

16. Fleming-Williams and Parris 1984, p.72. It is noted on p.44 that the dealer D.T. White of Maddox Street probably sold Constable sketches to Vaughan, and furthermore that while they were in White's possession they were apparently seen in 1853 by the French landscape painter Constant Troyon: Vaughan said that White had told him that 'Troyon came frequently to see these studies and desired much to become the owner of them had circumstances permitted.'

17. See Egerton 1998, pp.42-9. The painting was first exhibited in 1821; it passed to George Young; his sale Christie's 19 May 1866 (25), bt. Cox for Henry Vaughan, by whom presented to the National Gallery 1886. See in addition, the letters cited here at note 1.

18. Vaughan created an album/scrapbook in which he gathered together information on *The Hay-Wain* (it survives in the National Gallery Library: (O.S.) NH 695 Constable (J) Vaughan) but is not discussed in Egerton 1998. It includes a number of autograph notes by him, chiefly based on the writings of Leslie and Redgrave, a photograph, prints after the painting and various cuttings. Among them is a cutting from *The Times* of 17 March 1886 which records how his gift was announced in answer to a question in the House of Commons and greeted with cheers. Vaughan also owned the artist's full scale oil sketch for the *The Hay-Wain*, but did not show the two works together in his house, as from 1862 he loaned the sketch to the South Kensington Museum.

19. These works are divided between the collection of Tate Britain and University College, London.

20. The works by Stothard bequeathed to the National Gallery of Scotland are: *Seven Illustrations to Burns' Poems* (D NG 900), *Nine illustrations to Burns' Poems* (D NG 901) and *Illustrations to Sir Walter Scott's 'Rokeby'* (D 3511 / D 3512 / D 3513 / D 3514 / D 3515 / D 3516 / D 3517 / D 3518). Other works from Vaughan's collection by the artist are in the collection of Tate Britain.

21. Postle 2005, no.90, pp.268-9: John Henry Foley (1818-74), *Sir Joshua Reynolds* (by 1874), marble, 203 × 78.7 × 66cm. Bequeathed by Henry Vaughan 1900. The other works in Tate Britain are *Flaxman* by Henry Weekes and *Gainsborough* by Thomas Brock. It is curious that Vaughan does not seem to have commissioned a portrait of Turner; this may have been because he was aware of what an unprepossessing figure the artist was.

22. *The Athenaeum*, 2 December 1899.

23. Finberg 1909.

24. Forrester 1996, p.40.

25. Forrester 1996, p.21 and ref. 147.

26. Quoted in Dawson 1988, p.39

27. Cormack 1975, p.vii.

28. See, for example, Waterfield 1998, pp.42-4.

29. Parts of his collection passed to the Victoria & Albert Museum and the Whitworth Art Gallery, Manchester; see Melva Croal 'Collections of Turner watercolours in Nineteenth Century Manchester' in Nugent and Croal 1996.

30. Hewison, Warrell and Wildman 2000, pp.194-8.

31. The Dublin cabinet does not bear any labels or inscriptions, however, some of the frames have paper notes adhered to their *versos* which are inscribed with Vaughan's name and address (e.g. on the frame of no. 2404); these are almost certainly in Vaughan's own hand and may have been applied when he made loans. It accommodates thirty-one works – the extent of the Dublin Bequest.

32. Sloan 1998, pp.19-20.

33. See Joll, Butlin and Herrmann 2001, p.273.

34. A series of letters outlining the practical arrangements for these loans survive in the archive of the National Gallery of Scotland.

35. The other family members buried in the vault are Vaughan's brother George (died 1874), sister Mary (died 1845), and her husband Philip Sanction (died 1866).